1

JM

SIX FANTASY ARTISTS AT WORK

DREAM MAKERS

MICHAEL KALUTA
BERNI WRIGHTSON
CHARLES VESS
MELVYN GRANT
JULEK HELLER
CHRIS MOORE

Edited by MARTYN DEAN
Text CHRIS EVANS

Paper Tiger

A PAPER TIGER BOOK

© Dragon's World Limited 1988
© Text Chris Evans 1988
© Photography Martyn Dean 1988

Paper Tiger Books
Dragon's World Ltd
Limpsfield
Surrey
RH8 0DY
United Kingdom

Produced, edited and designed by
Martyn Dean
Text based on interviews between the artists and Martyn Dean.

Metropolis pictures by Michael Kaluta and *A Midsummer Night's Dream* pictures by Charles Vess used with permission of the Donning Company/Publishers.

British Library Cataloguing in Publication Data
Evans, C. D. (Christopher D.), *1951* –
 Dream makers: six fantasy artist at work.
 1. Visual arts. Special subjects. Fantasy
 I. Title II. Dean, Martyn
 704.9'4
ISBN 1 85028 067 3
Printed in Spain
SIRVEN GRAFIC Barcelona
D.L. B-39.917-88

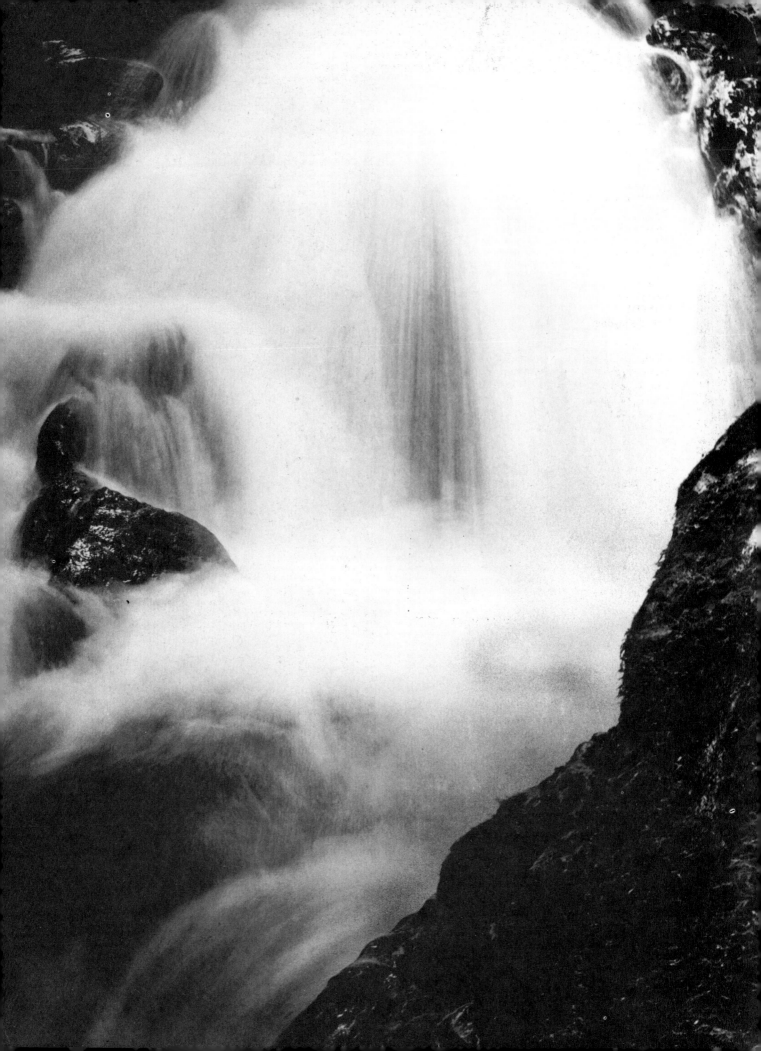

CONTENTS

INTRODUCTION

Dream Makers features the pictures of six modern artists who produce commercial illustrations for books, comics, advertising and a variety of printed products. Their styles vary greatly, but they all work in an area which can be loosely called fantasy art, employing ideas and images which go beyond realism into the landscapes of dreams, nightmares and imagined futures.

Such imagery is a dominant feature of modern life. The 1980s have seen a phenomenal increase in the popularity of fantasy, and its visual motifs are widespread in everything from books and posters to video games, television and cinema. The old heroes of the past — cowboys, cops and soldiers — have been superseded by starship captains, warriors with magical weapons, bizarre but cuddly aliens whom we happily take into our homes. Today's children are growing up in a world in which the exotic has been thoroughly domesticated.

It is tempting to see fantasy art solely as a form of escapism. As we lurch towards the end of the twentieth century, haunted by fears of nuclear weapons, pollution and plagues, we need some respite from the often grim realities of everyday life. Much fantasy art presents not only a more colourful universe but one in which there are none of the ambiguities which make real life so troublesome: heroes are heroes, villains villains, men muscular, and women idealized visions of femininity. Or we may be presented with soaring visions of human

progress — gleaming spacecraft carrying a triumphant human race across the universe, reducing personal problems to insignificance.

But this only partly explains the appeal of such art. Sheer novelty may alone suffice, a playful fascination with things we have never seen but may at least imagine. So we indulge ourselves in a form of controlled dreaming which may be just as important to our well-being as the unpremeditated dreams of sleep.

Dream Makers explores the ideas, inspirations and working practices of six artists who have forged their own distinctive styles of illustration. It is, however, important to be aware of the commercial context in which they work, for the actual content of their pictures is often heavily determined by the briefs laid down by their employers, be they publishers, advertising agencies or TV companies. Their art is seldom produced in isolation from outside influence; it is responsive to the demands of the marketplace. But at the same time it, in turn, influences the appetites of that same marketplace, especially when a talented artist is able to bring something fresh and exciting to a brief. Popular art feeds off mass culture and helps to shape it. Through interviews with the artists themselves, *Dream Makers* investigates just how these influences work, from within and without. The book is a celebration of the artists' work and also an exploration of just why we find fantasy so compelling.

CHRIS EVANS

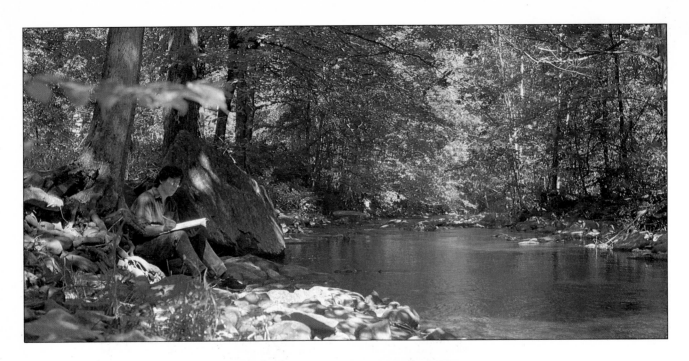

CHARLES VESS

Charles Vess lives and works in Upstate New York, his studio looking out over an expanse of greenery. The natural world is close at hand, and for Vess it's a landscape which closely mirrors his own artistic concerns. In his pictures he shuns technology and all the refinements of the modern world, preferring to concentrate on *milieux* where the imprint of the human race is minimal at best. Therefore it's all the more surprising to discover that until recently Vess lived for eleven years in New York City, perhaps the most urban environment on Earth.

Three features are immediately striking about Vess's artwork — intricacy and sinuousness of line, rich yet restrained colours, and the powerful pre-sence of nature in the raw. Though human characters always populate his pictures, they are very much figures in a landscape, a single element in a larger whole. Far from dominating the environments which they inhabit, they are interwoven with it, a feature not necessarily more important than any other. In fact, the central image in many of his pictures is the tree with convoluted roots and branches, around which all the other elements of the picture dispose themselves.

'I just respond to growing, organic things,' Vess confesses. 'I like them to be as alive as a person in a picture. Trees seem to me to be sucking power out of the earth and shooting it up into the sky. They

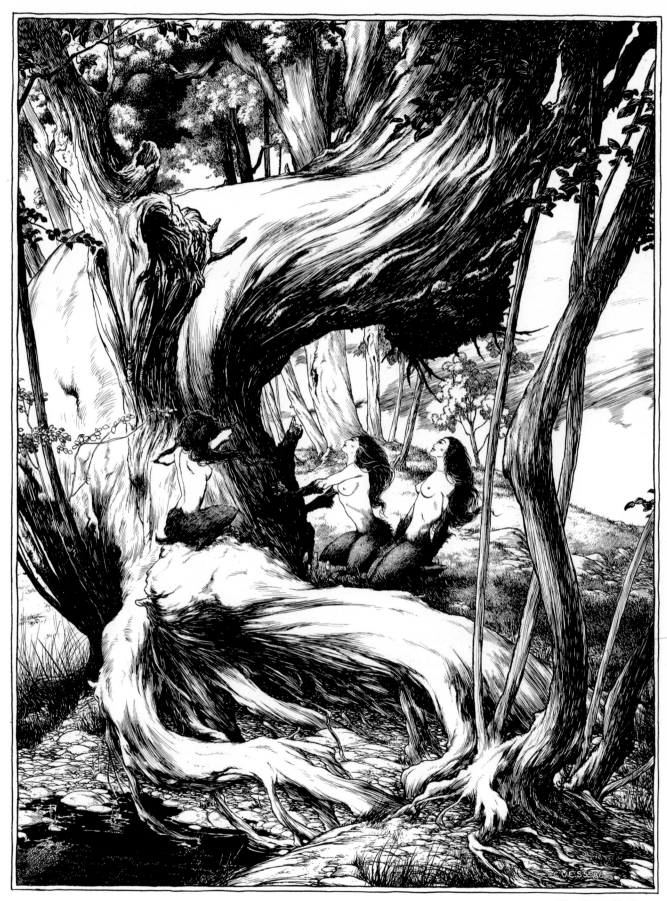

The Dryad's Song.

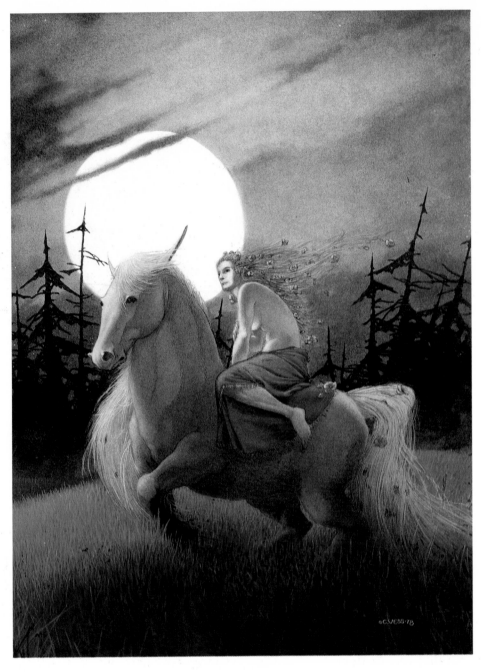

The Earth Witch.

are the intermediary between the earth and the sky. Trees look very old, and I like that feeling.

'The pictures I do don't really deal with a specific reality. It's more the atmosphere that's creating the reality — the trees or the rocks or the bushes. None of these are meant to be specific — none of the trees are real trees.' So what effect is he after in his work? 'Shape and motion and emotion all should come from everything in the picture. If you have a person in a picture with a couple of ill-placed trees — that's not very interesting. But if you have the person there and have the trees wrapped around him, then you've created an emotional space that's more interesting.'

Vess is perhaps best known as a comic-book artist, though he has always produced pictures

The Horns of Elfland.

solely to satisfy himself. He begins with a pencil sketch which is then inked over and the pencil lines erased. Even when doing comic-book art, he does his own colouring. 'To me, it's as important as the pencilling and inking. It adds the three-dimensionality to the shapes and it can add atmosphere, time of day, where the sun is, where the light is coming from — all that sort of thing.'

Rather than employing oils or acrylics, he uses shellac-based coloured inks with an opaque white for highlights. 'I've been using these inks for 15 or 16 years, and I like the fact that you can glaze with them. It's like an oil technique, but they dry instantly.'

The muted yet technicolour glow of his pictures is an effect which Vess attributes to 'a combination of being in love with Walt Disney's *Fantasia*-type illustration and loving Arthur Rackham at the same time.' He also cites Dulac, Heath Robinson and Howard Pyle as influences. Often there's an almost

Victorian feel to his illustrations, as in his drawings of fairies as children in flowing gowns. 'I don't know whether Howard Pyle did fairies, but he was a very big influence on me. The reason I gave the fairies long gowns is the same reason as when I draw a dragon, it becomes very long. It's a design element as opposed to a figure so that you get a strong movement out of it. It's the same with the trees and the rocks and everything else in my pictures — I tend to think in terms of the movement in the picture.'

The design of Vess's work is always strong, with a harmonious balance between spaces, shapes and figures. 'When I first started art lessons, my teachers said I had a natural sense of design. It's also something I've ever learned from modern abstract art. The level at which it appealed to me is in the placement of objects and how you can make a space whole.' As an example, he cites some of Picasso's paintings. 'When I'm scribbling on a

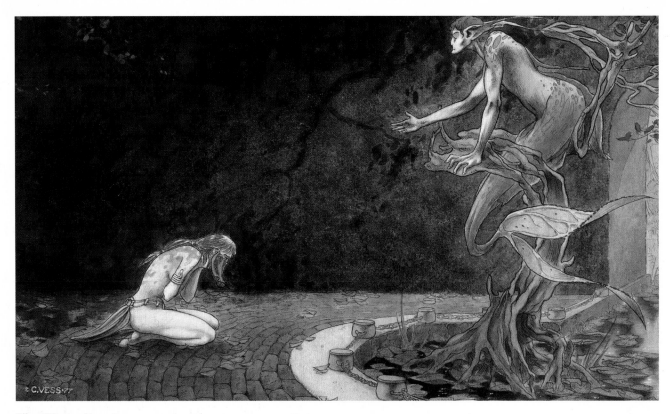

The Changeling.

sheet of white paper, I try to get the scribbled object to where it all balances out. When a picture feels right, it's designed right.'

For want of a better word, Vess is content to be described as a fantasy illustrator, although he's not interested in the whimsy of elves and goblins or the blood and guts of heroic barbarians. 'I like a subtle story, and barbarians are generally guys who knock over the other guys!' Equally, he has little affinity with the hi-tech gloss of science-fiction illustration. 'Science fiction to me is Art Deco, it's hard edges. It doesn't really interest me in the same way that drawing a car doesn't interest me. My mind doesn't think that way. I like organic things and a medi-aevel look — back when man was still living with nature rather than fighting against it and trying to conquer it. To me, a giant superhighway is straight and knocks everything down in its path. When you're driving along it, you completely ignore what you're going through. The older the road, the more

it's going with the land and the more you know where you are.'

Vess emphasizes that such considerations are not a conscious influence when he's actually drawing. 'I've just dealt with them for so long in my art. I like olden things best.'

Like most freelance illustrators, Vess has done a variety of commissioned work, from book-jacket illustration to comic art. He feels his work is better when it's not too tightly briefed. 'I come up with more interesting ideas and I'm a lot looser.' He doesn't take on any projects which he won't enjoy doing, or he turns the brief into something which he can execute according to his own interests. 'You have to figure out a way to trick your mind into thinking it's a picture you want to do. Recently I did a comic-book cover of a giant muscled man with steel claws. I don't really have any interest in drawing that sort of figure, but I thought of him as a dark, almost werewolf creature, and I drew him

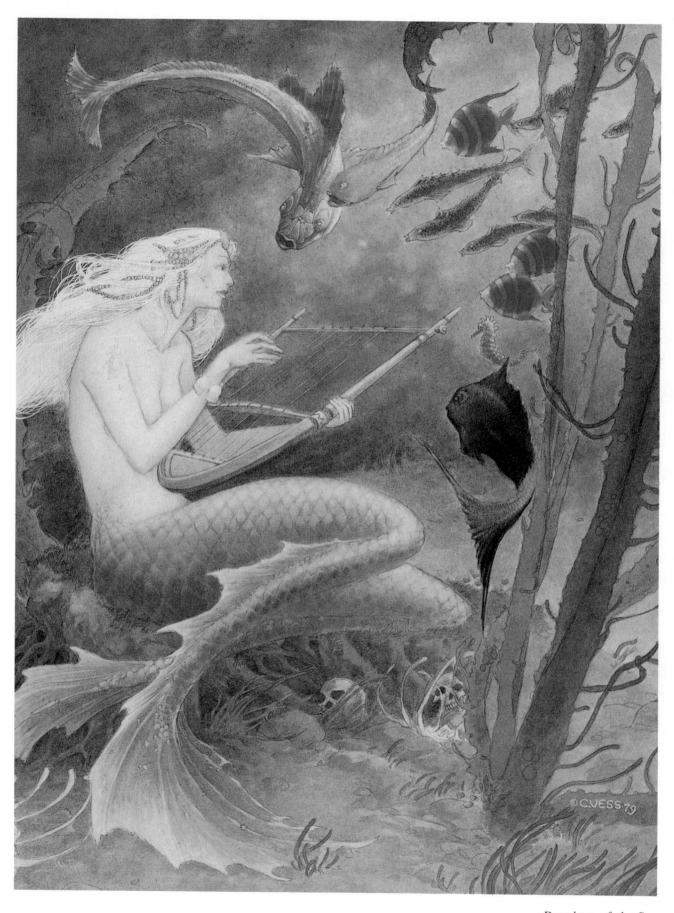

Daughter of the Sea.

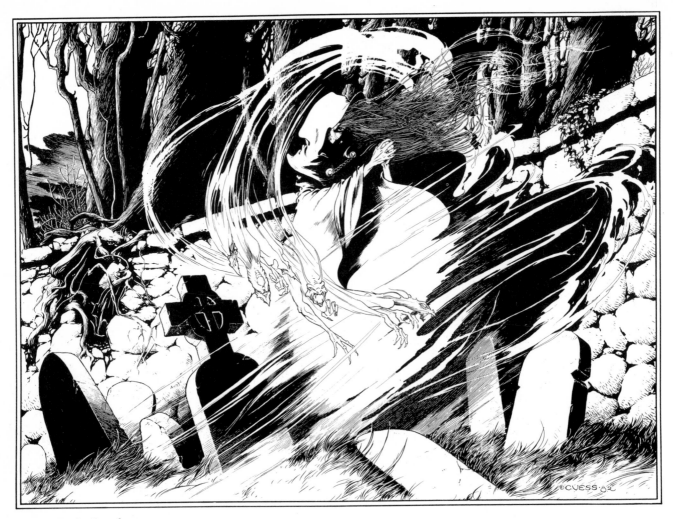

Comes Lady Death.

that way, not ever thinking of him as the superhero type.'

Vess tends not to do many book jackets. 'The style I work in, which is line and colour, is not what many art-directors think sells. They want highly rendered, over-rendered, over-detailed pictures. I'm capable of it, but it's boring. And who wants to make a living being boring?' As his work has become better known, he tends to be offered commissions more suited to his style and interests. Even so, he will still occasionally be asked to draw something like a spaceship. His response is brief and to the point: 'Sorry. I don't draw spaceships. What do you think you have here?'

Vess recently completed a *Spiderman* graphic novel for Marvel Comics, not only drawing but also writing the story. 'It's set in Scotland and the theme is city magic — as represented by Spiderman — versus country magic. I write whenever I can. If you write the story you can be sure you're going to draw whatever you feel like drawing. I found a way to come up with a story that the editors would go for and that I would want to draw.'

What does he see as the difference between comic strips, comic books and graphic novels? 'A comic strip is *Peanuts*. A comic book is *Spiderman*. A graphic novel is a longer piece than a standard comic book. It can be more mature in its subject matter and more complex in its printing capability. Regular comic books are printed using plastic

16

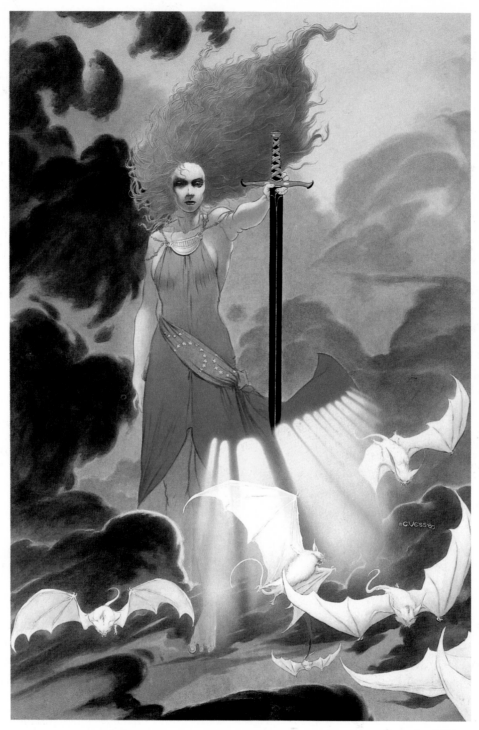

Sword of Dawn.

plates on the worst possible paper — paper that will dissolve soon! It's very difficult to achieve a subtle look with these.'

Does he find the comic-book world a cut-throat business? 'I keep out of the politics of it. I prefer to draw than get angry.'

The format of the commissioned work obviously influences the design of the art, but unforeseen frustrations can still arise. 'If you're doing a book cover, you have to know basically where the type is

Beyond the Fields We Know.

The Buttercup Race.

going to be. Occasionally the publishers will decide to use a different kind of titling or to add a subtitle, or to put it in an area that it has no business being in. This makes the whole picture look cluttered and ugly. If they tell you beforehand, then you can take this into consideration. Every shape in the picture makes or breaks the design.'

As with most illustrators, Vess ideally prefers to concentrate on pictures which arise totally out of his own interests. Sometimes the end result is later used commercially, as with his *Daughter of the Sea* (page 15). This was completed some years ago when he was living in New York City and when, having little work, he sat around creating pictures for his own satisfaction. It was eventually used as a cover for a gaming magazine.

How does he generate one of his own pieces of artwork? He describes the origin of a poster-picture of *The White Goddess* (page 22) for an sf comic-book shop in Toronto called the Silver Snail. He

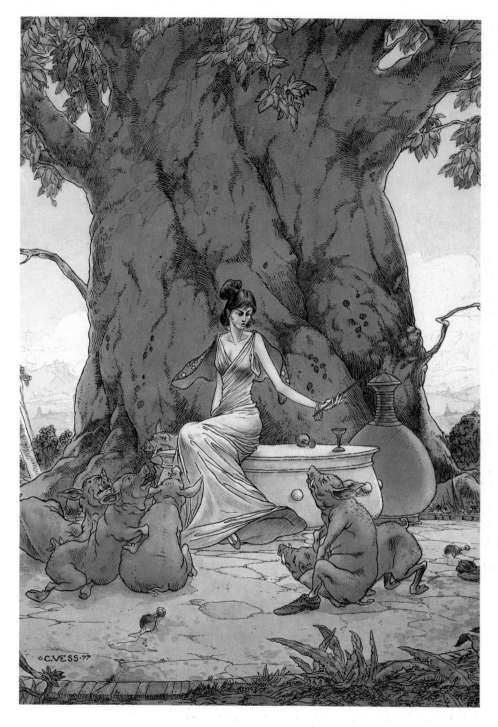

Circe and her Swine.

was given a loose brief at a convention, based on a sketch he did of a woman killing a dragon. The detailed content of the finished art was left open at this stage.

When the initial pencil sketch was complete, it was sent to the people at the Silver Snail. 'They asked for a few changes which made sense to me — things which I'd already thought about after sending the sketch off. They wanted a small black-and-white picture for publicity purposes as well as

Be at Peace and Enter In, a page from a comic book.

the full-colour poster-art. I redrew the pencil drawing, then did the outlines in pen-and-ink before tracing the outlines (with the aid of a light-box) onto another sheet of paper. I filled the black-and-white drawing in with cross-hatch and tones. For the colour piece, instead of cross-hatching and tone, I used colour — pure colour.

'It takes a while to learn when not to put the ink-line down if you're going to paint on top of it. There's one way to ink if you're doing a black-and-white illustration, and a completely different way if you're going to colour it.

'To me, the picture itself is a lover's tiff. The woman and the dragon were lovers, and they've had a serious falling-out, which is one reason why the dragon's tail is still wrapped slightly around the

Tree of Life.

woman's legs.'

Vess reads widely and draws much of his inspiration from the printed word. 'I used to read Tolkein-esque fantasy, but nowadays I read Scottish, Irish and some English novels that I would consider mystical because the people and the land have a magic working in them — the magic of life.'

One of his latest projects is an illustrated version of Shakespeare's *A Midsummer Night's Dream* (page 24). How did he approach that? 'I read the manuscript three or four times, then I started working on the characters, doing lots of sketches of things I wanted them doing. I thought of the feeling you get when reading the words and I tried to create a visual that went with that feeling. I also tried to interpret things in a different way from everyone

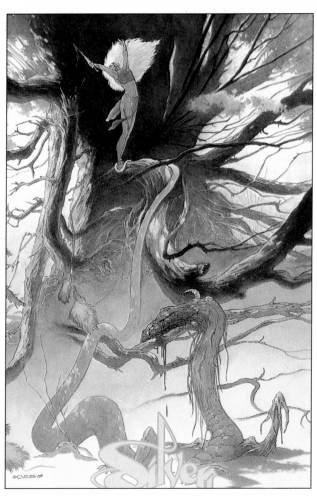

The White Goddess, pencil drawing.

The White Goddess, poster for Silver Snail.

else. For example, I had no desire to draw Theseus and Hippolyta, so in a couple of scenes I drew the metaphor as opposed to what was actually happening in the story. The rest of the time I concentrated on the "locals" — Bottom and his friends — and the fairies. I have absolutely no idea what an Athenian wood would look like, so I didn't attempt to portray one.'

Does the finished picture vary much from the original concept in his mind's eye? 'I try not to see it in detail in my mind. I can if I think about it a lot, but I try not to because I want what I think of as the mood and the feeling. I depend on the happy accident. When you're drawing, you might put a line on the big white sheet of paper which makes a

nice shape. You work on that and it takes you off into another dimension of imagery. I don't want a picture I might look at and think, "I've seen this art before". I want to be surprised by a book I read or a picture I draw.'

Thoughtfully composed and subtly tinted with gradated hues, Vess's pictures convey a feeling of delicate restraint in their execution. They are never too cluttered or over-detailed. Unlike some artists who overdo their effects, Vess seems to know just when to stop painting. 'That's just a process of maturing in your art. I know the feeling I want in a picture before I know what the picture's going to be like.' The fact that he's got a line-drawing to work from helps. 'You don't have to over-render

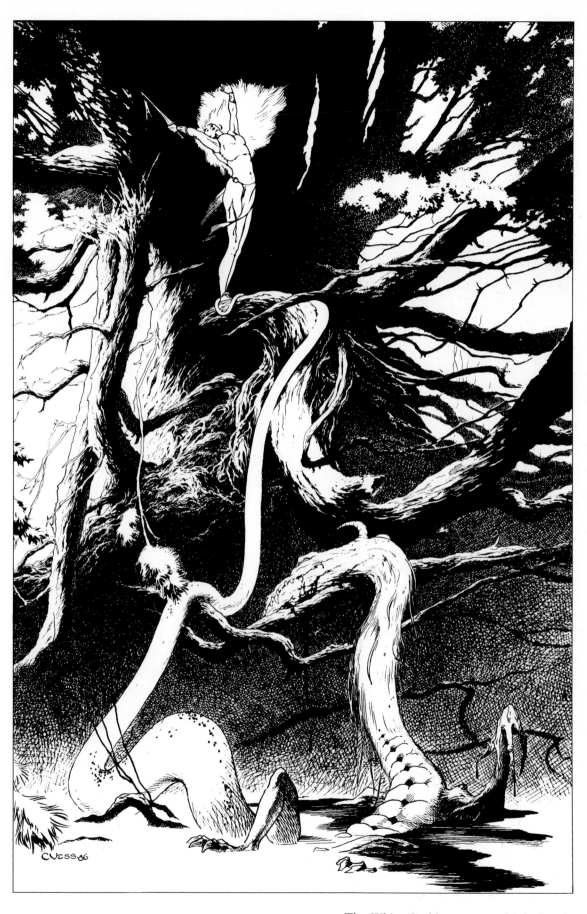

The White Goddess, pen and ink drawing.

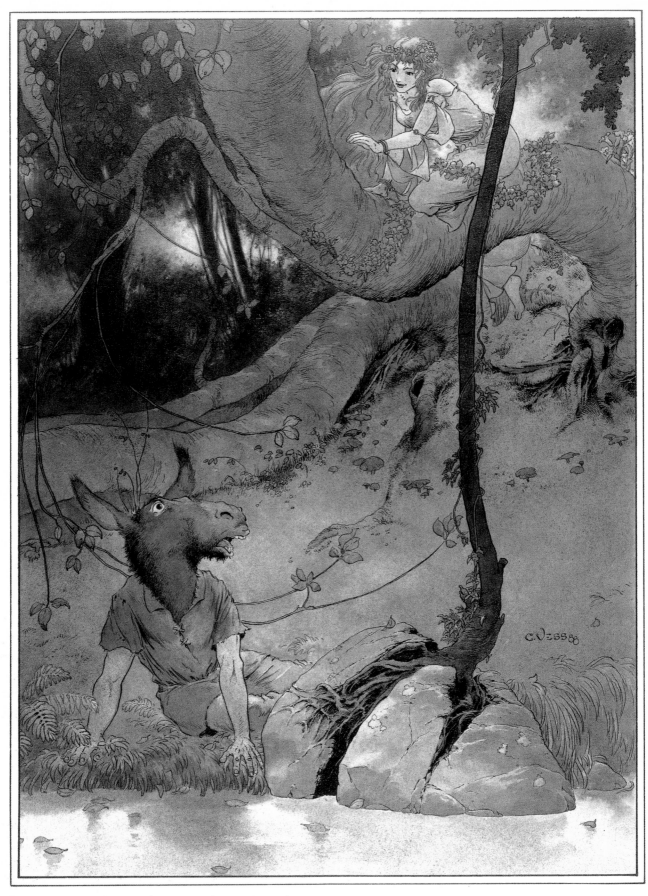

'*What Angel Wakes Me from My Flowery Bower*',
from A Midsummer Night's Dream.

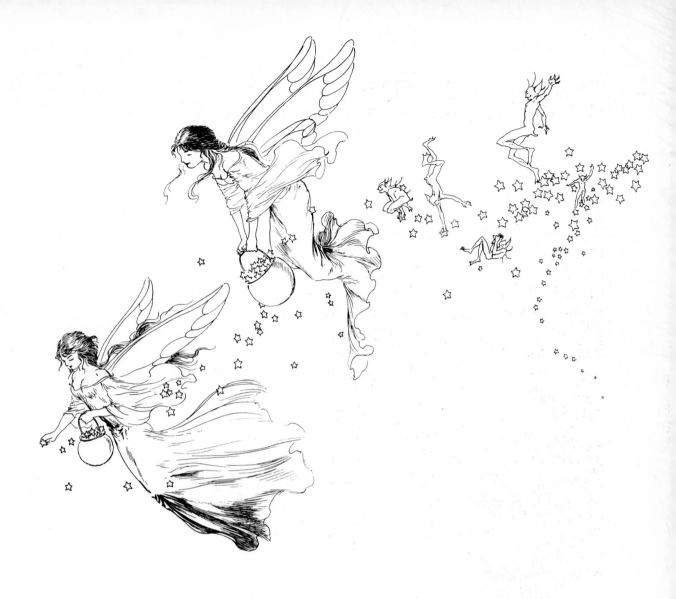

Fairies from A Midsummer Night's Dream.

everything to make it solid because you have the outline. The objects are there, no matter what you do to them. If you have the feeling and the atmosphere in your head, when you get that on paper you can stop instead of having to keep going and render every toenail just right!'

Vess only seldom draws direct from nature, though he has studied it closely in the past. 'I think my way through it rather than look at it for real. For example, if you're going to have the roots of a tree growing in a crack in a rock, you don't just suddenly open the rock. You think about the rock and you think about the tree, and then you crack it.'

What does he see as the important themes in his

art? 'Just nature being alive.' There's a sense in which his affinity for earlier times when the human race lived closer to nature masks the often harsh realities of such an existance. His pictures sometimes exist in that twilight period known to the Scots as 'the gloaming', where cruder details are softened or darkened, everything made more mellow. Vess is unrepentant. 'What can I say? I'm a romantic. My work is about the rock as superhero. The tree as superhero.'

He describes one of the effects he's currently striving for in his work: 'The magic of the sunlight coming down throught the trees, dappling across the rock and the person and across the grass and making all of it one object.' He's not seeking an expression-

istic effect where the images are reduced to particles of light and colour. 'I want the dapple *and* the objects behind the light. This has been in the background of my work so far, but it will come more to the foreground. It's something I'm still figuring out how to handle technically and conceptually.'

All the time Vess lived in New York City, he never drew urban scenes, and now he's interested to discover how his move to more rural surroundings will affect his art. It seems unlikely that he'll suddenly start drawing cityscapes and other features of the man-made environment in compensation. Recently he has been able to travel more, and this offers new opportunities for providing him with fresh inspiration. Not long ago he made a tour of Scotland and did pencil drawings of various locales while he was there — misty landscapes over lakes, cairns on the summits of hills. It was clearly an enriching experience, not only from the point of view of encountering different kinds of scenery.

'I like to relax and read. When you come back from somewhere else, a lot of what you've read and what you've looked at and the people you've met affects you. It's really good to hit another culture.' He enjoys drawing from life, though until now he's had precious little opportunity for it. His new home, buried deep in the kind of countryside he loves, puts his subject matter at his back door. 'I'm going to go down to the stream and draw some of those roots. I'll get to make the whole land around here into one of my drawings.'

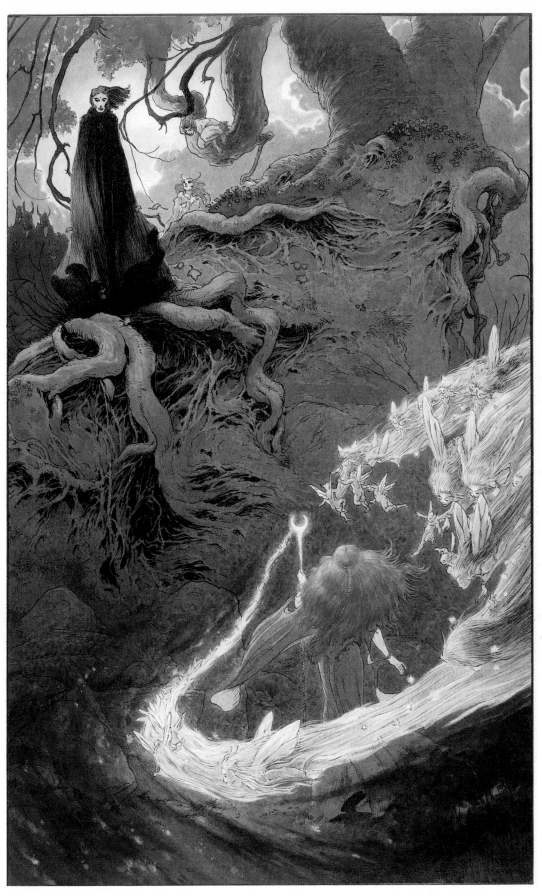

'Hand in Hand with Fairy Grace',
from A Midsummer Night's Dream.

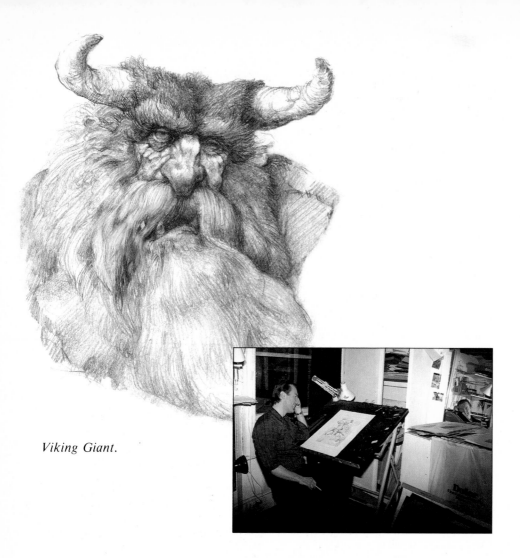

Viking Giant.

JULEK HELLER

In much of Julek Heller's work the images are big and bold and ancient. His illustrations for the book *Giants* feature heavy-browed men, massive of frame, with luxuriant growths of hair and shadowed eyes which stare out at us from either side of craggy noses. They recall the old gods of Germanic or Slavic folklore, figures ravaged but unbowed by the rigours of their long lives. They have a forbidding quality, a stern and muscular power which tells us that they are not to be trifled with. Most inhabit untamed landscapes of mist and snow and barren rocks.

'I was brought up on a lot of children's fantasy,' Heller remarks. 'My mother was always reading to me — Andersen and people like that. Later I came upon Batman and Superman. I've always been attracted by fantasy. I did a lot of objective drawing and life drawing at art college, but it never seemed the ultimate form of expression for me. I was always using it to draw something else. I suppose it all goes back to childhood — my pictures are unfulfilled fantasies which have become my work.'

Heller's illustrations certainly have a classic fairy-tale bent, featuring as they do such things as knights, giants and dragons. He also seems to have a special fondness for prominent snouts or noses; whether fish, flesh or fantasy-creature, they thrust out at the onlooker, emphasizing the gaping mouths, the staring eyes, the stumps of teeth. Even when playful, they have a devilish quality which echoes

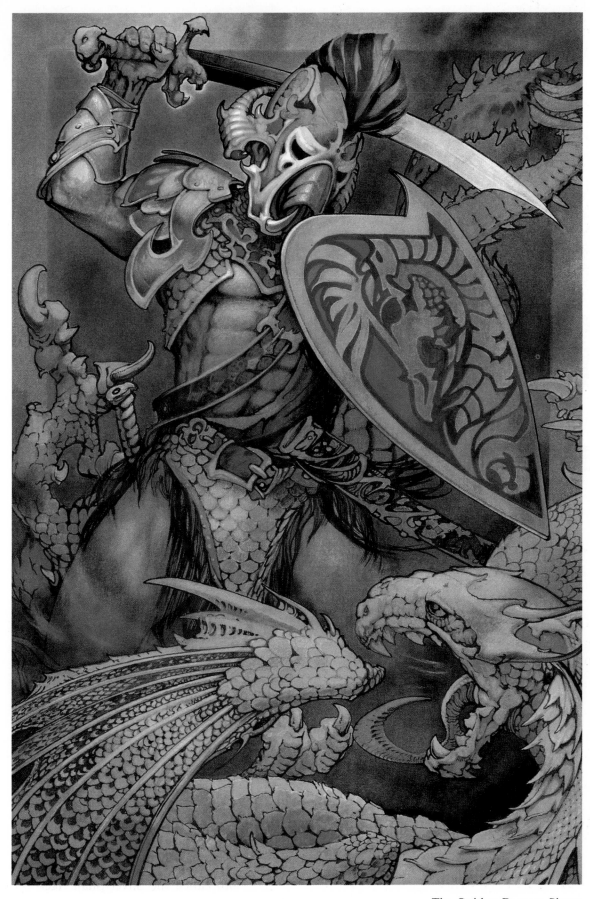

The Golden Dragon Slayer.

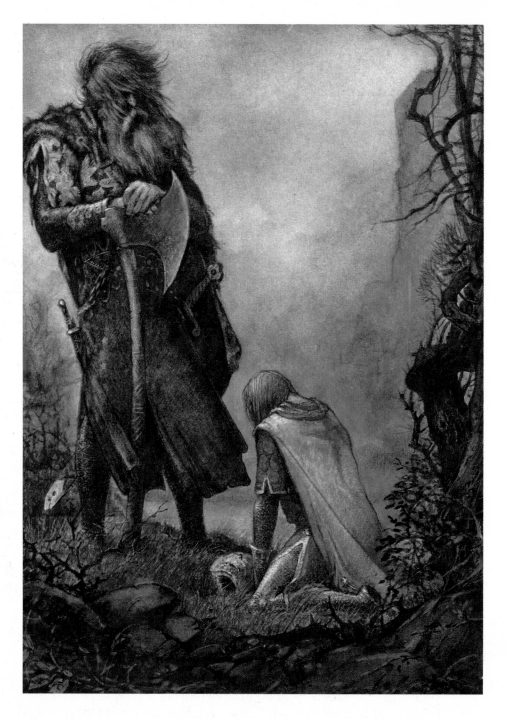

The Green Knight.

the kind of fevered dreams that are often the province of childhood. Sometimes figures of all shapes swarm and mass, leering, rearing their heads, sucking us into their worlds. Or solitary figures stand sentinel, positively warning us against trespassing in their realms. Whatever their attitude or disposition, they have an intensity of presence on the page that is filled with undertones of anger and violence.

Heller was born in England of Polish parents, and he lives in London with his wife and children. He studied at the Oxford School of Art and later at

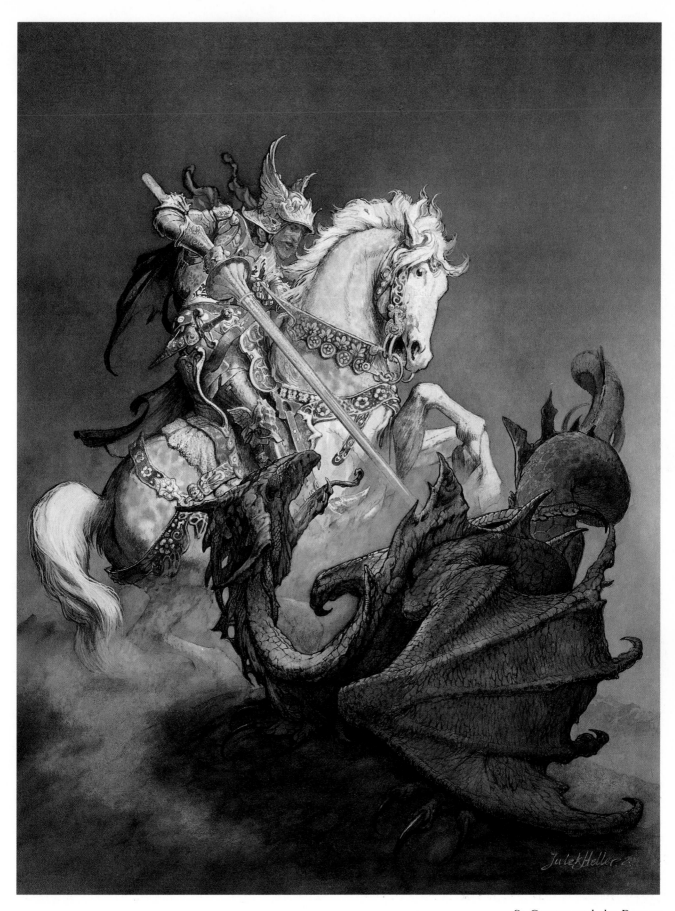

St George and the Dragon.

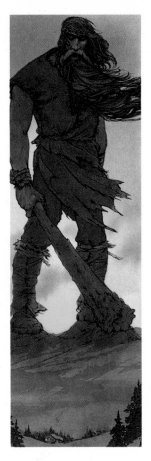

Giant.

Chelsea, doing mostly fine art. Afterwards he taught for a while in a secondary school before going to the Royal Academy for three years. He then returned to teaching but also began doing textile designs for companies such as Heal's. 'I put ideas from painting into textile design, and gradually I started doing more figurative work within the fabrics. I did that for about four years, and then one day I decided that perhaps I could use the skills which I'd acquired doing life-drawing to earn a bit of money because I couldn't stand teaching. I started with the BBC.'

He worked on the children's television programme *Jackanory* doing, among other things, a Tolkeinesque fantasy about a little gnome. At this stage Heller had been working for three years as an illustrator and was on the point of giving it all up

and returning to teaching because he'd made very little money out of it. Then he was offered the opportunity of doing illustrations for *Giants*.

To some extent, the future direction of Heller's work was shaped by taking on the project. 'The first book I ever had published was a pure natural history book. Fantasy work was just one direction I chose to go in.'

After *Giants* was finished, Heller visited New York City, where he was introduced to an author who was interested in producing a book of mythical American beasts based on folklore and regional tales of various bizarre creatures. 'After we'd met, I went home and did a sample drawing. I got so excited that I then did several samples. I was certain that publishers would just jump at the book.'

Unfortunately, the project fell through, but

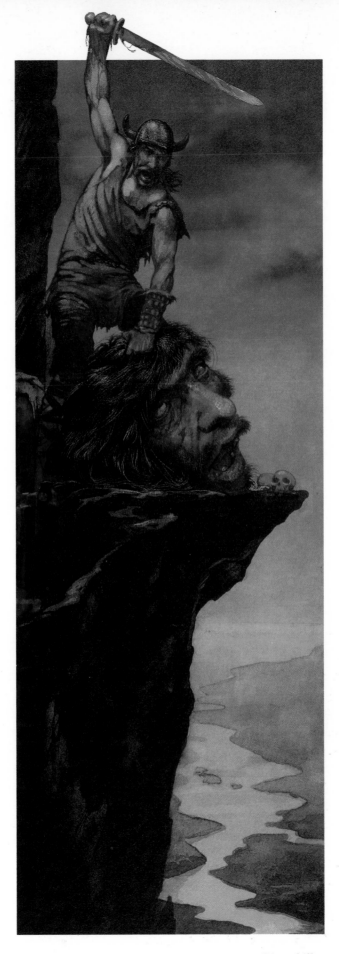

Giant-killer.

33

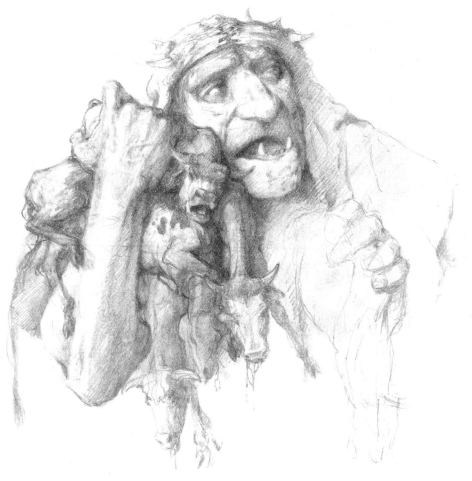

Cow-thief Giant.

Heller's pictures still exist. They were intended to look like natural history plates. 'I tried to conceive them and draw them as if they were creatures that really existed, in the traditional style of the original natural-history watercolour artists.' Because there were no visual references, Heller worked hard to find the right texture and look and image for the creatures, which at that stage only existed as written descriptions.

Among the animals featured are the Squonk, a sad creature with a tendency to cry itself to death because of its ugliness; the Goofus Bird, which flies backwards; the three-legged Tripodero, which can fire clay pellets from its snout and also inflate and deflate itself so that it's able to hide in cracks in rocks; and the Whirling Wimpus, which can spin around so quickly that it becomes invisible. The Squonk, the Goofus Bird and the Tripodero are all shown on page 44.

'I had to look for something like an attitude, or get some idea of what the skin would look like. In the case of the Squonk, I couldn't get inspired. Then one day I was cutting up a chicken and I realized that the skin had the right feel to it. It was moist and just *squonky* like the Squonk itself!'

Another of the animals was reputedly put on display in the real world, in a dark tent. 'It looks the way it does in my illustration because I based it on a very poor photograph of what looks like a buffalo skin with horns sticking out of it.

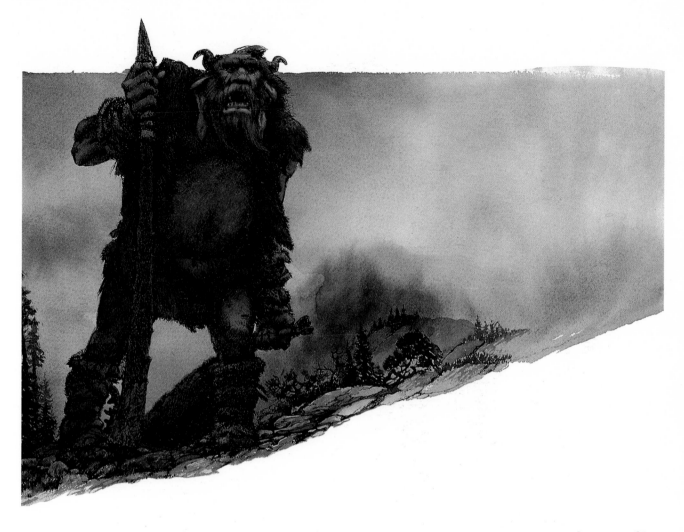

Giant.

I imagined the rest from the description — apparently it has green eyes and nostrils that looked as if they had flames in them.'

Heller's pictures always start as pencil drawings, which are usually traced and then coloured. He uses textile dyes for his colours, an echo of the days when he worked in fabrics. 'It's very thin and translucent and it creates beautiful colour harmonies. It's very difficult to use, but I find it better than watercolours.' The white is gouache. He doesn't use inks, but he has no objections to mixing media.

Is he concerned with the durability of his artwork? 'I'd like to think that it would last a long time, but it isn't my main concern. I've noticed that the yellow has faded in one of my pictures.' To

Heller, that's not necessarily a bad thing. 'You never know, something interesting might happen.'

Though the subject matter of his work tends towards the soft images of fantasy as opposed to hard-edged science fiction work, Heller claims to have no special preference for the former. A recent sketch of a piece of machinery was executed precisely because he had been concentrating on organic things and wanted a change. 'I don't find any difference between drawing one thing and another.' For a fantasy paperback series he designed a border so that the different images on the cover of each title would have some unity and continuity. For this, he was able to draw on influences from his days in textile design.

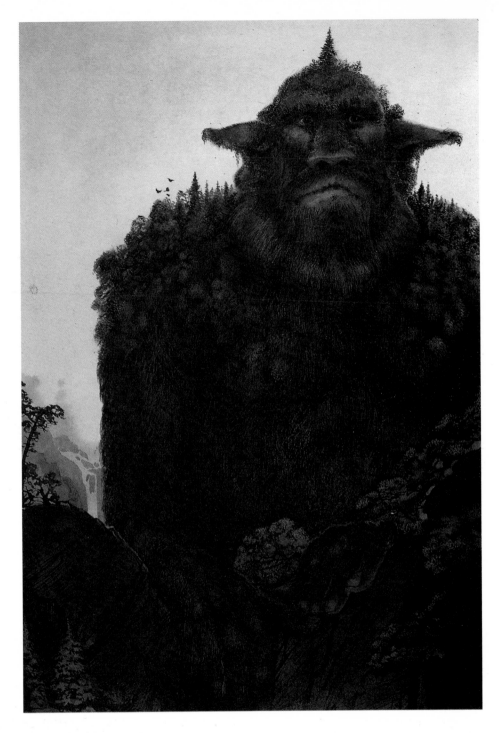

Mountain Giant.

Heller's images sometimes come from unexpected sources, as for example when he based a dragon on a coffee-stain in his kitchen. 'I do look out for unusual shapes. The other day I photographed a piece of bird-dropping which was just the perfect shape of a bird taking off. The way it had splattered on the ground suggested some long-legged bird taking off in a great panic. That very often sparks off an idea you can then develop.

'The reason my best stuff works is that it comes

Giant in the Lake.

from nowhere — it just appears. I may modify it, but I use my feelings to do it. I don't use any other kind of judgement. If it feels right, it's got to be right.'

For this reason, Heller rarely enjoys being tightly briefed when doing commercial work. 'When you're commissioned to do something and people tell you exactly what to do, they eliminate your feelings straight away. "Don't feel about this, just think. But don't think too much because we've already thought it out." By the time you've designed what you think they'll like, it's not as good. Fantasy is something that should live within you. If other people start fantasizing for you, it's all over.' He much prefers to undertake jobs like *Giants,*

where he was given a practically free rein in his choice of imagery. Is there another project of that nature that he would like to tackle?

'The idea of dreams is a wonderful excuse for anything. I come up with images in my head that are often fantastic but I haven't the time to produce them and they couldn't be commissioned. They just appear. I'm that kind of illustrator.'

Does he do much work purely for his own satisfaction? 'I've done some. They're kind of abstract, a distillation of the very detailed work. They don't have a subject as such. They're very private, and very few and far between.' Does he feel frustrated by the pressures of having to produce work according to detailed specifications? 'You make the

Storm Giant.

best of a bad job, but I feel as if I'm strait-jacketed, even within fantasy, which is where it hurts. I don't mind being briefed one hundred per cent if it's an advertising job and they need something specific. But if they say to me, "You're a fantasy artist — do something and we'll tell you what we don't like in it!"— that's where it ends for me. The greatest fun is coming up with the rough. The rest is just a duty to the publisher.'

Heller sees himself as a frustrated art director. He has many ideas but no proper outlet for them. 'My drawings come from a very spontaneous way of working, but I like to impose a certain artificiality, a kind of style on them because it puts

a certain kind of tension into them.'

In one of his latest illustrations, *The Golden Dragon Slayer*, all the shapes are designed to convey that feeling. 'The gear the warrior's wearing is meant to make the shape feel as powerful and as violent as possible.' The initial image which is sketched comes very freely and is often very loose. The colouring and fleshing-out stage is more of a craftsmanlike process in which the images are made more formal and dense on the page. The process of transforming the initial image into something different greatly interests him.

'I think it goes back to my days in textile design where you had to draw things and repeat. You had

Quarrelsome Sky Giants.

Sketches of Giants.

your concept, and then you repeated the drawing several times to show how the whole thing would look. What I used to like about it was that my original sketch, say of flowers, would go through a very long process from my drawing table to yards and yards of material coming out of a factory with the original design imprinted on it. My silly little idea was now in mass production. For me, that's one continuous process, the whole thing — it's just that other people have done different stages for me. A bit like Andy Warhol on a domestic scale!

'I think these highly finished things lose out in some ways, but they also gain an artificiality which I quite like. It must be the craftsman in me. Probably my spontaneous sketches are the real me, but

I've overcome the barrier of hard work in that I'm now quite prepared to draw over my sketches again. I know that after a few hours of work I'm going to have something that I would not have naturally produced.

'I've seen a lot of wonderful things produced by craftsmen. I've seen all the effort that goes into it, without which the object wouldn't exist.' As an example, he mentions the kinds of design which William Morris produced. In his own work he says he's been greatly influenced by the floridity of Art Nouveau.

In some senses he sees himself as a frustrated jeweller and would like to move into three-dimensional sculpture. 'That's because you could

The Giant's Thorn.

then make it all real. On paper it's just an illusion. It would have to be approached in a completely different way, but it would be wonderful to see some of these extravagantly silly things in my pictures as solid objects.

'A lot of this fantasy stuff is left over from my childhood. I couldn't draw it well enough then, and I'm now finishing it.' Though he has children of his own, he still feels he's working primarily for the child or the teenager in himself. 'Some of the illustrations are for the me of my teens that I'm still trying to satisfy. Perhaps then I'll move on. And of course there's a whole market of people out there who also like that sort of thing. I want to do it well

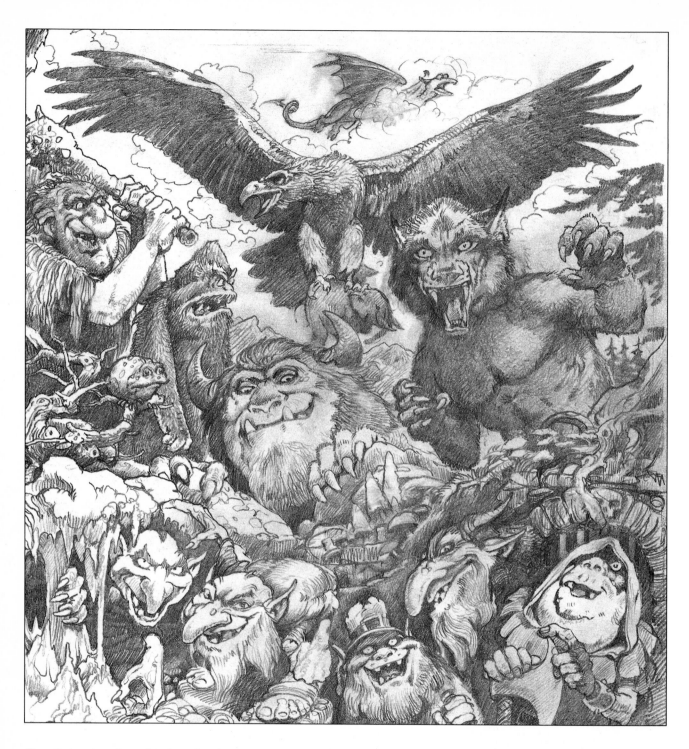

Pencil drawing for a bestiary book cover.

for them, too, because they are quite discerning. There's too much bad illustration around.'

Heller is concerned that he shouldn't sound pompous, but clearly he speaks out of a passionate involvement in art, both as a producer and a 'consumer'. He appreciates well-drawn things where the subject matter is not important, but at the same time the artist in him can admire works where the craftsmanship may not be first-rate but the involvement of the creator has been intense.

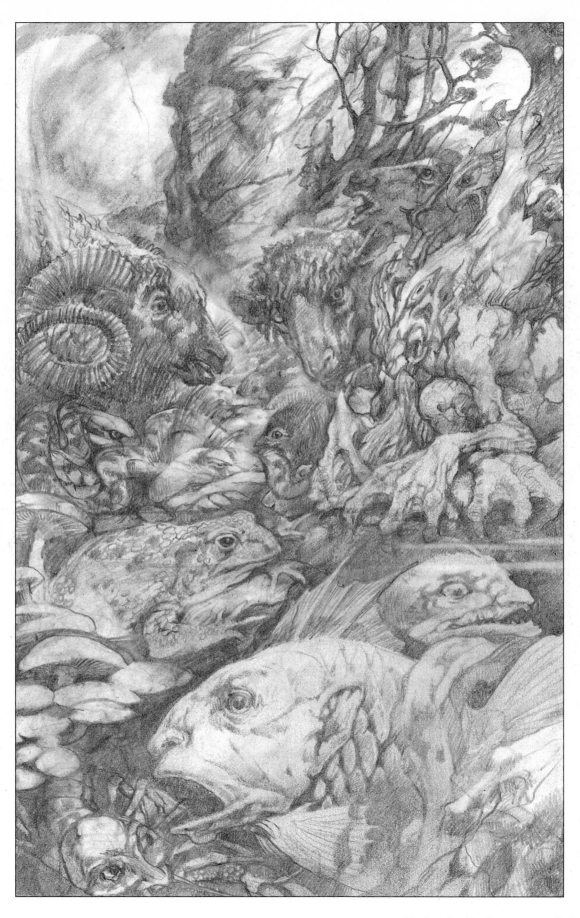

Under the Enchanter, pencil drawing.

43

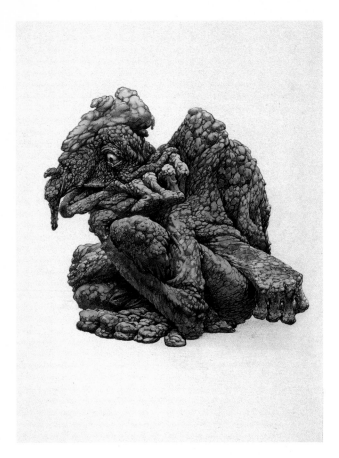

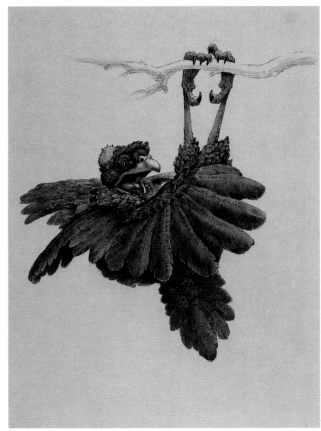

The Squonk dissolves in its own tears because it is so ugly.

*The Goofus Bird flies to the north backwards when migrating south. Hence the bump on its head.
Silly isn't it?*

Creatures from North American folklore.

The Black Demon Hodag was exhibited in a dark tent in a travelling carnival. It was probably a creature created by mad taxidermists.

The Tripodero rises up on its telescopic legs, inflates its body and fires clay pellets at its enemies. We have here a fine piece of animal ordnance.

Now a mature artist, Heller sometimes finds it strange that he's still drawn to the kind of illustration which does appeal to child-like yearnings in him. 'Occasionally I look at it and think, "What am I doing with all this stuff? Why am I drawing knights fighting dragons?" But equally I might sit down to do a still life and have similar feelings. I'll think, "What's so interesting about drawing a few apples?" But there is probably a way of drawing apples that could make them an exciting subject for me.'

Heller is never short of the basic raw material for his art. 'I get too many ideas. A lot of them die because of commercial commitments. Images come from every direction. I'd love to be totally free of commercial commitments so that I could churn out

Pencil sketch for Songs of Summer.

the images, just to get rid of them.' The frustration is sometimes increased because a brief may suggest interesting ideas to him which he knows he can't use in the given context and will therefore go to waste. For him the idea is the most exciting stage and the finished art the most important thing. All the work in between this is often a grind.

'Sometimes when I go to bed I just can't close my eyes and go to sleep for the slide-show of work that I've never done and never will do. If I've been working very hard on a drawing throughout the day, I might go to sleep and dream that I'm starting the drawing again from scratch. In the dream I'll draw it all day, then wake up exhausted — and without the duplicate drawing!'

Songs of Summer.

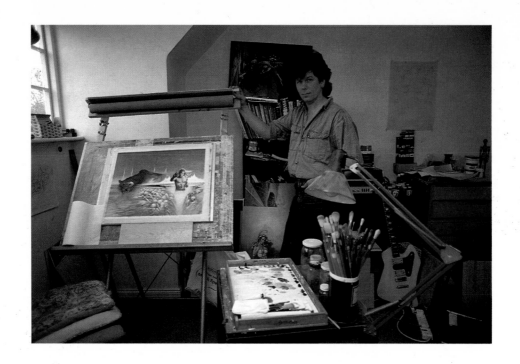

MELVYN GRANT

'If you have anything creative in you, it will come out in various forms. When I'm working up here, sitting in the same position at my drawing board for a long time, concentrating on trying to put some sort of image down on that space in front of me, the breaks that you take are important. What I like best is to plug in an electric guitar and blast hell out of the neighbours!'

Music has always been important to Melvyn Grant. Playing in a band takes him out of his studio and has, he feels, given him a freshness in his painting. 'I also like to be able to build musical instruments. You can do anything you want providing you understand the medium you're working in. Once you do that, and if you've got the ideas, then you can transfer from art to music or to writing. It all comes from the ideas in the mind.'

Grant's pictures are notable for their strong com-position, their convincing portrayal of the human form, and the interesting use of comparisons and contrasts in their imagery. Barbarian warriors stand with swords whose curved blades echo the sweep of the shield and the horns on the helmet; a half-naked woman who seems to rise up out of the dust is backdropped by a soaring curved tower whose arching spires in turn mimic the antennae of a rearing alien monster; futuristic soldiers with weapons that resemble bulbous harpoon-guns emerge from a spaceship of whale-like proportions. In many of them the air is filled with electrical discharges, so that if we could *hear* them they would be filled with noise.

'What's frustrating sometimes when you're painting a picture is that you put in a single mo-ment, encapsulated in a flat, two-dimensional plane, but in fact I could write a whole story

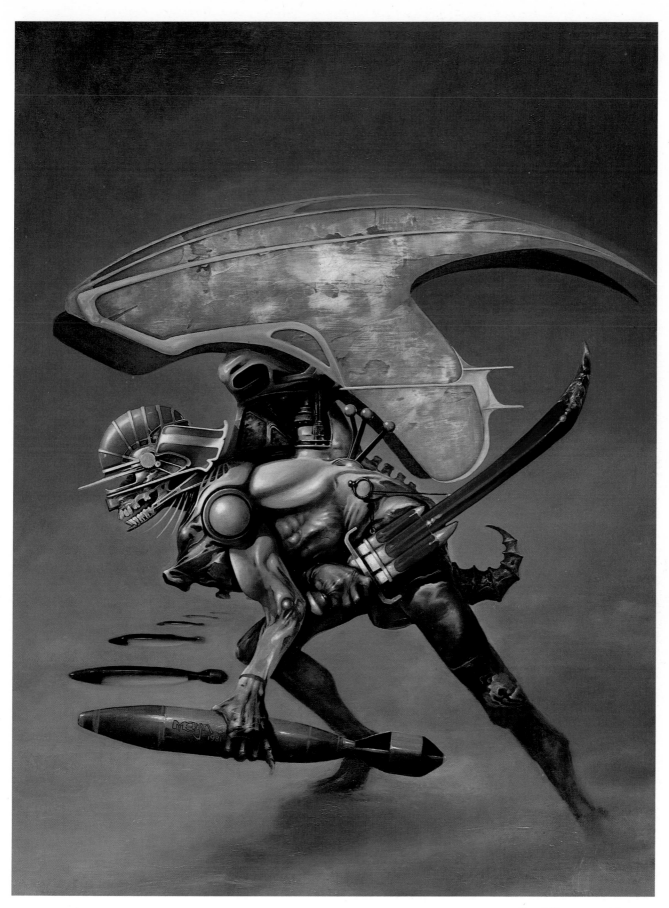

Steel Tzar, record cover.

49

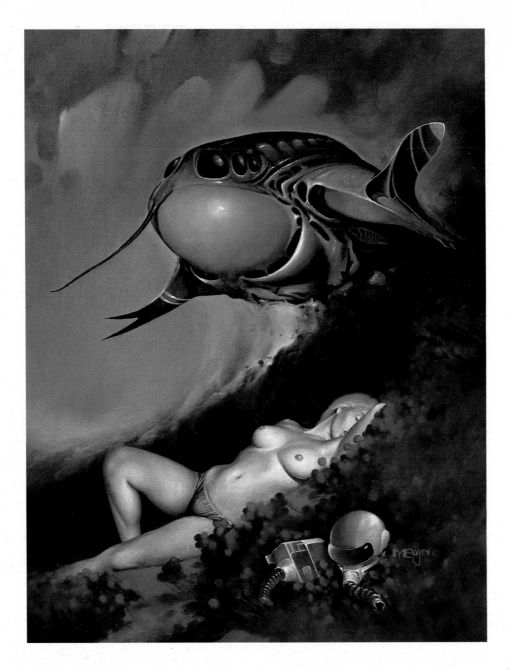

Floating Worlds.

around it, put music to it, and add sound effects to the action.'

Much of Grant's artwork is done for paperback covers, and he's perhaps most noted for fantasy-type illustrations featuring barbarian warriors and savage creatures rather than the harder technological images of science fiction. Surprisingly, he says, 'I was really into science fiction, not fantasy. I just seemed to get roped into it, perhaps because of the ability to draw the human figure — women and muscle-bound guys with swords.' He has, in fact, done his share of spaceships, which he renders as rounded craft with fins and curves.

'I don't like the idea of flying concrete buildings because I don't think they will be like that in the future. With electronics, for example, we've gone

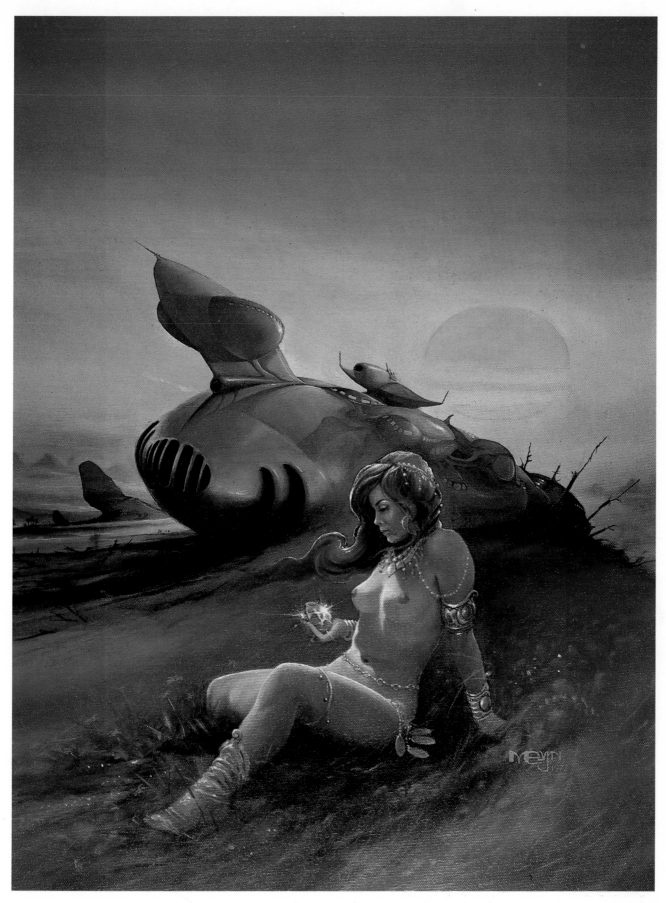

Sapphire.

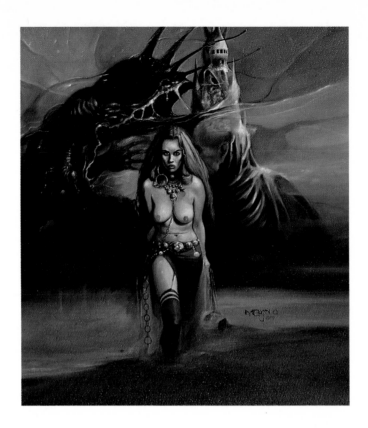

Slave-girl.

from a gas state with valves to solid state with transistors, and the next step will be a liquid state. I think in the future they will clone things and grow things. I think it will be possible to make moulds for metals which are perhaps controlled with opposing electrical charges to hold the shape. Organic shapes are the way it's going to go. Look at the shape of a shark — it's designed perfectly. You can't get a boat with a better design for going through water.'

Grant has such an affinity for organic shapes that in many of his paintings there's not a straight line to be seen. Heroic fantasy may not have been his original preference as subject matter, but he's become an expert at it, doing many variations on the basic theme of a warrior with a sword. Usually they're shown poised for action rather then actively

hewing limbs or heads from the bone so that the feeling conveyed by the picture is one of *menace* rather than actual violence.

'I've always tried to portray the moment before the attack. If you take the poster for the film *Rambo* which shows him standing there, his machine-gun blazing — it looks absolutely daft. But if you've got the warrior standing there with a couple of swords which he's just used and is about to use again, it's more effective. He's looking at you, and he might be smiling, but you know he's going to get you. At the same time, he's wearing a silly hat or something — and that only makes it all the more horrific because you know the clown is a terrific killer.'

Seemingly incidental details enhance and reinforce the effect. Mists and clouds swirl and loom in

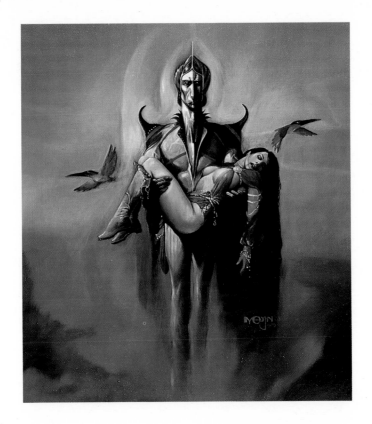

Door Through Space.

the background, or bright veins of electrical discharges fill the air. 'It's like a plasma. What I've done is to put outside the tension that's within the character.' Another way of achieving a similar effect is to have the actual face of the warrior hidden under a helmet while the shield the warrior is carrying bears a face that screams out all the violence and rage. 'The shield's showing the battle cry, if you like. But the warrior is not often doing anything except come at you. He's got the intent.'

Making the warrior faceless is often more effective as far as Grant is concerned. 'It's like the film *Duel*, where the lorry chases the car along a highway. You never see the driver — just a black window. This is the same thing — you've got a suit of armour that is the ultimate warrior. There's no identity to it. You can't see the expression; you

can't latch onto it. Sometimes it's hard to tell where the armour or helmet ends and the actual body of the warrior begins. All that can be seen are eyes and teeth. 'That's really what people go by. Most animals will have a certain look in their eyes and show their teeth.'

Even when he's doing more science-fiction paintings, his warriors tend to have a quasi-barbarian look, their spacesuits horned and encrusted like ceremonial armour or chain-mail, their guns baroque things which combine elements of swords, rifles and power-tools. 'It's like taking Vikings or Hell's Angels and upgrading them into the future and giving them Black and Deckers to use — Black and Decker zap guns!'

Often the figures, looming out of mists or striding across dusty surfaces, have their feet wholly or

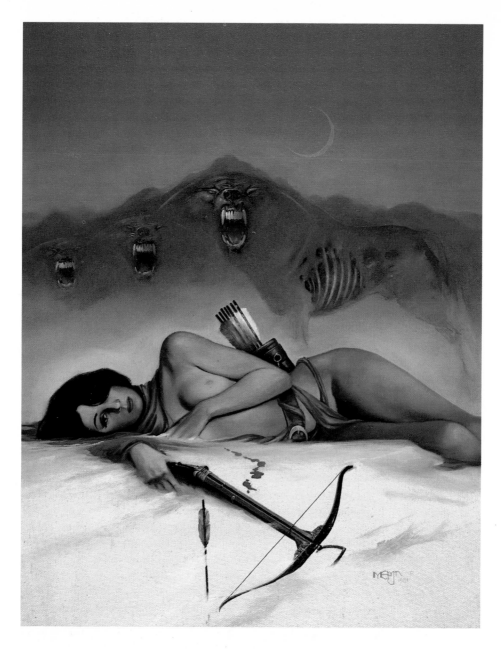

False Dawn.

partially invisible so that there's sometimes a sense
that they are very manifestations of the earth or air.

The human beings in Grant's paintings are often
counterpointed with animals or other beasts. Fol-
lowing a lifelong obsession, he once did a whole
series of dinosaur pictures, and would be happy to
do a whole book of them. 'I don't believe dinosaurs
looked like the paintings we see of them. I don't

think they were cold-blooded, either. I think they
were fast-moving and probably a lot more intelli-
gent than we give them credit for. The bodies of the
pteranodons and pterodactyls were very well
perfected for flying.'

In his portrayal of more fantastical creatures,
Grant tries to avoid hackneyed elements. Usually
they have a savage or horrific aspect and have

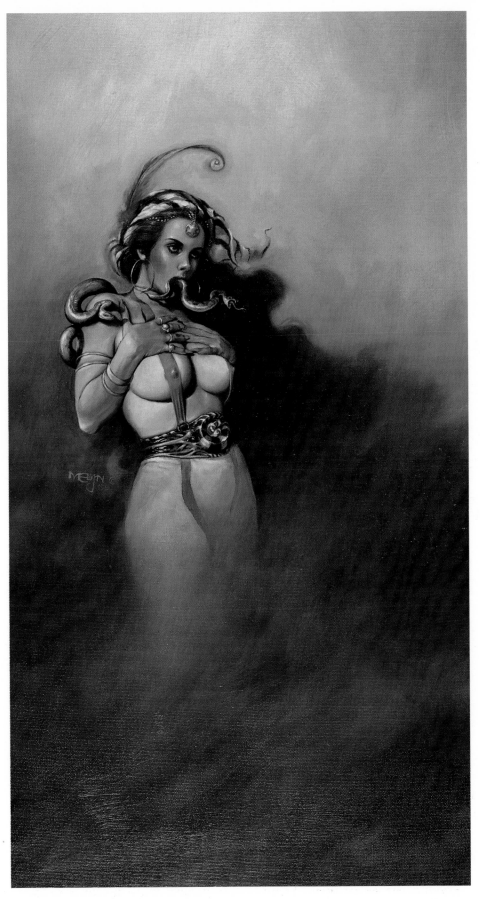

Serpent.

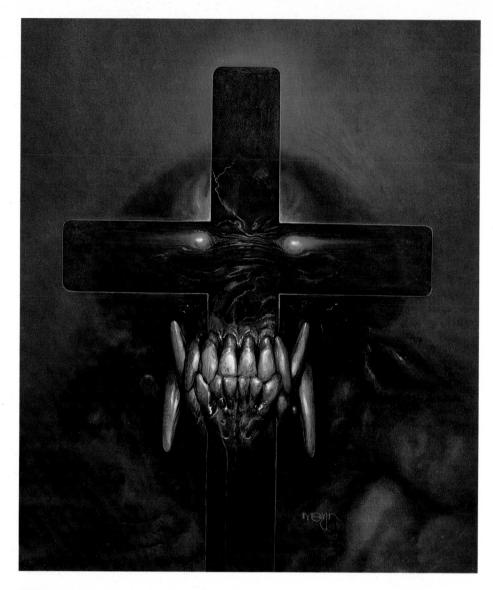

Nightchurch.

features borrowed and recombined from crustaceans, insects and invertebrates. The black slug-like creature in one painting is meant to contrast starkly with the body of the woman in the foreground while also sharing a certain similarity in the softness and yielding qualities of the flesh.

An even newer painting, *Jaws* (page 62), features a slavering red alien with multiple eyes and savage teeth and claws. 'I want to make my aliens as different from us as possible, and also to try a different slant that maybe no one else does. The spider has multiple eyes, so why not an alien? It's nice to double up in things.

'I suppose it's crustacean-insect based. I painted it like that because the publishers wanted plenty of teeth in the mouth. It gave me a chance to get over

Death Rides Out.

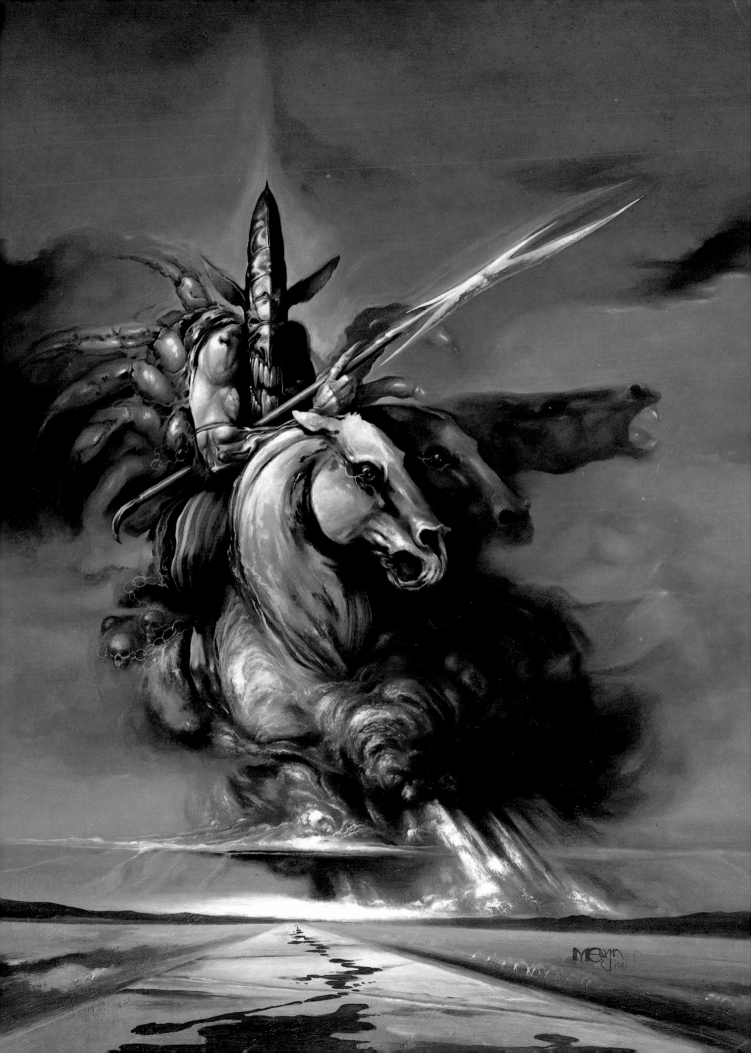

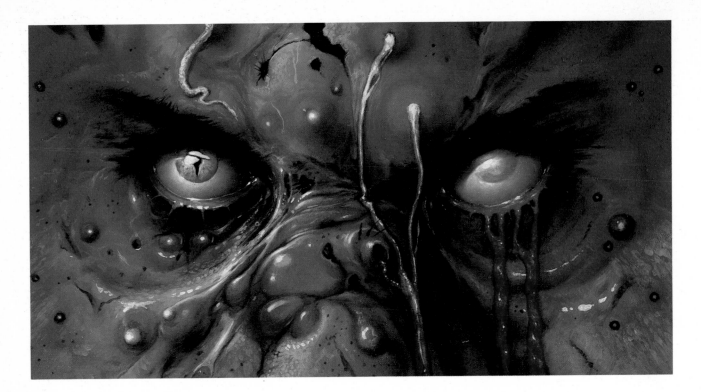

Eyes.

my annoyance with the film *Alien*, where they've got the two sets of teeth going in the same direction rather than having them opposing as nature would do. You've got mandibles going from side to side, and jaws going up and down. The teeth are almost human-like but it's got no lips to cover them up.'

The double sets of eyes and the misty red background almost create the impression that the creature is out of focus and cannot be seen completely clearly. 'I wanted it to be vague and definite all at the same time to encourage the imagination to dwell on its nastiness. If you could see it totally and you looked at it for long enough, it might be really horrible, but you'd get used to it. All you're really aware of is lots of sharp teeth and claws, a red carapace and fleshy, bloody bits.'

There's no hint of the mad staring eyes that we often find in classic horror beasts. Was this deliberate? 'Mad staring eyes based on human eyes or certain kinds of animals' eyes with different irises, or even fishes' eyes — they're all things we're actually familiar with. I wanted to portray the intelligence behind the creature — a totally alien intelligence. It looks nasty, and it also looks like it knows what it's doing, and it isn't going to give you any mercy at all. It would be quick-moving, too. And I bet its breath smells!'

Grant produced book-cover art regularly in the 1970s, then took a long break in advertising when the market seemed to dry up before returning to the field. The new paintings are in general less violent in their imagery, with a more pastoral feel to the scenery. There's also less nudity in his female figures. Grant puts this down partly to the changes

Alien.

58

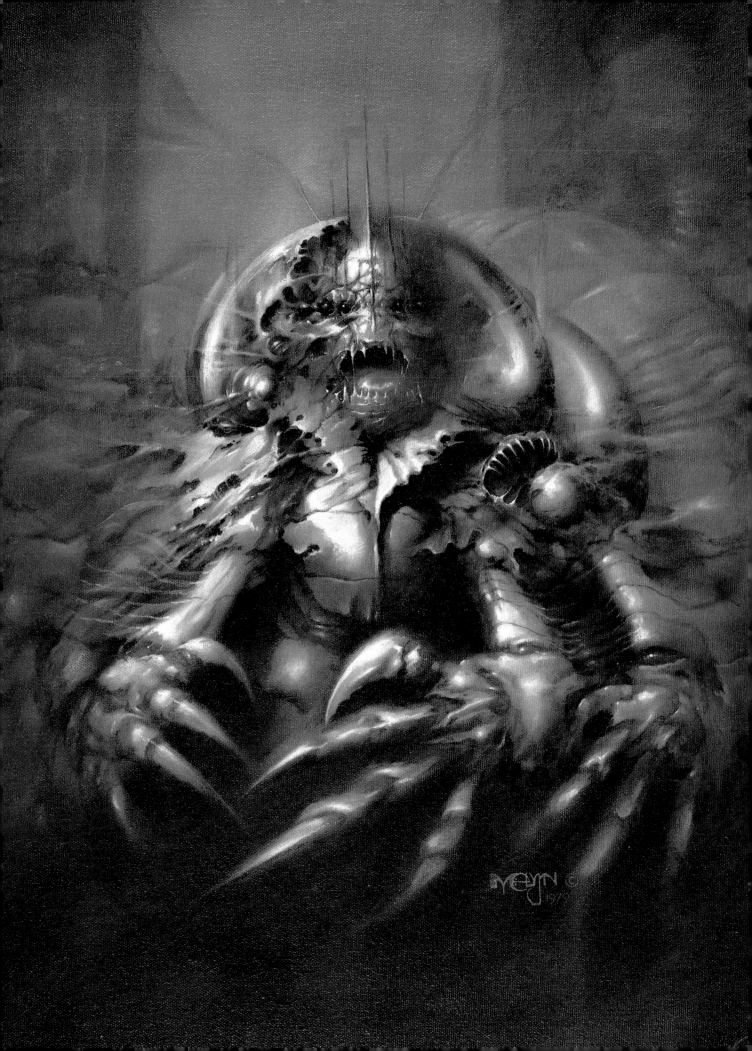

Dream Master.

in attitude on the part of publishers, who seem to favour less explicit sexual imagery these days, and partly to his own desire to make his pictures more sophisticated. 'What I'm doing now is to retain the elements that were good in the older stuff but have less blood and guts.' He wants to *imply* his effects more than specifically stating them, and he draws a parallel with shock-horror films, whose effects have become more understated because the public was sated with full-blooded approach to violence and horror.

The recent picture, *Queensblade* (page 67), illustrates this shift in direction. A woman stands calmly in the placid landscape of a flowered field, with a distant hazy mountain and a wide expanse of pale blue sky in the background. She holds a dagger at her side, but the only emphasis on the wound in her chest is the bright red of the blood itself.

'The idea in the story is that a queen comes to an age when she can no longer have children. So she takes the Queensblade knife — which is a black iron dagger — and stabs herself in the heart, allowing her blood to flow into the land. This is what the people believe will keep the land fertile. In the story there was the queen and her daughter, and I portrayed the daughter so you've got the beauty of it. I depicted her having stabbed herself in the heart, but it's not actually having any effect on her. She's bleeding down into the earth, and the white flowers she's holding are turning red with her blood.'

The more subtle imagery of his recent work is something he feels he would like to have achieved from the outset, although he wants his current

Heros for Wargames.

60

Jaws.

Dinner.

paintings to have a similar impact to the earlier ones. 'I'm trying to put a different slant on it. Make it even more horrific or nasty.'

As in all of Grant's pictures, the human image in *Queensblade* is strong and convincing. 'I like figurative work. The woman in the *Queensblade* picture looks very much like the model I used for the painting. I've enhanced it in little ways, but not a lot. The knife she's holding was actually a kitchen knife in real life.'

He uses models for reference when time and money allow, taking polaroids of them as the basis for his figures. 'In earlier days I used less references. But I believe that if you're going to develop as an artist, you need references of some sort.' He admits to enjoying painting the female figure, and sometimes his pictures arise because he has a pho-

tographic reference which he particularly likes and wants to paint. With book jacket covers, he reads the story if he has to. 'I used to read the books all the time, but it's very time-consuming.'

All of Grant's paintings are executed in traditional oils. 'I don't like using acrylics. I don't think they're very good to use, and they don't suit me. I buy the best fine artists' paints for their lasting qualities and hopefully their intensity of colour and the fineness of the pigment which makes the actual painting easier.' Does he do an underpainting first? 'Sometimes. It varies. I might just paint on the background I want.'

Unlike many commercial artists who prefer acrylics because their speed of drying helps to speed up the production of pictures, Grant positively enjoys the slower drying qualities of oils, which

63

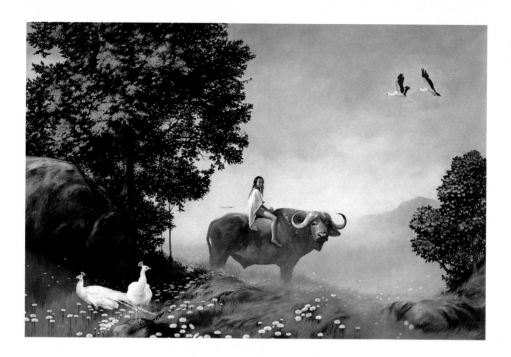

Bufflo Girl, early version.
Bufflo Girl, reference photo.

allow him time to work in the wet paint, stippling and blending the colours to achieve the effects he wants. Originally he did large paintings on canvas board for book covers, spending up to two weeks on a given piece. 'In those days I didn't do them purely as financial things — it's not necessary to do them that size for a book jacket. I tended to use the size as an incentive to start a painting, and I used to think I'd do more with them or use them for other ideas. But it never turned out that way because you always have to move on to the next

job.' Nowadays he works two sizes up from the finished size book cover.

He finds it hard to cite specific influences on his work, thought he does admit there's sometimes a hint of Maxfield Parrish in his use of colours. 'Everything you do is related. Maxfield Parrish himself said his technique of working wasn't unique to him. I think we all feed off each other. I'm influenced by what I like. There are a lot of artists I like, or certain bits of an artist's output that I like.'

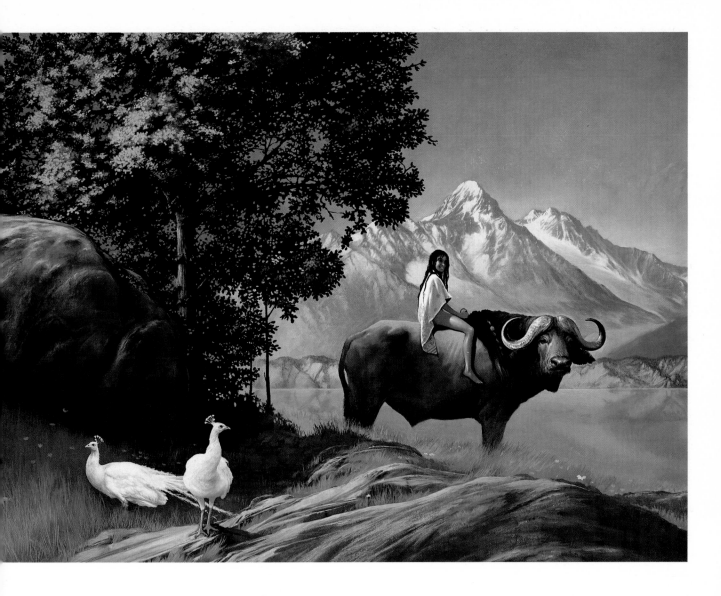

Bufflo Girl, final oil painting.

What about Frank Frazetta, to whom his work has sometimes been compared? 'I like Frazetta's work. I admire what he does. But I was doing well-developed figures when I was at art school, long before I'd ever heard of Frazetta. Then I see his work and I appreciate that he's doing what I'm thinking or feeling. I was well influenced by da Vinci when I was at art school. It wasn't so much his subject matter as the technique — the layout and the quality of it. The way he did a particular figure and the way it came across. The standard of the work of the old masters and the techniques they used are just amazing.'

How does he cope with being a commercial artist in the modern world, producing paintings which will usually appear in the format of a book cover? He cites the particular consideration of wrap-around covers from the artist's point of view: 'The painting goes at an angle, really, because the publishers put the computer price-code in a box at the bottom on the back of the book, and on the front you've got the titling, which is usually at the

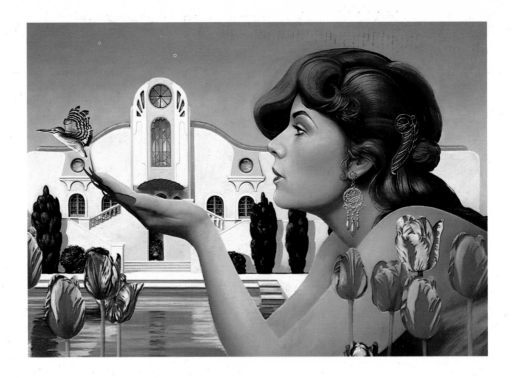

Tulips.

top. So the meat of the picture goes from the bottom right up to the top left. Which is quite interesting. To balance up a picture properly you tend to put the main eye-point off-centre.'

Frustrations often arise when the painting reaches its final form as a printed cover. 'You spend a lot of time getting the colours and the balance just right, and then they make an awful mess of it in the printing. I found that especially disappointing when I first started doing covers.' Hasn't the situation now improved, as colour printing techniques have made advances? Grant agrees that the reproduction of the pictures is usually better, but it can still be spoiled in other ways. 'When you've put a lot of work into a cover

painting, you can visualize how it's going to help sell a book. You imagine how it would catch the eye on the bookshelves. But sometimes that can't happen because the publishers put terrible type all around it and all over it, and it just kills it dead.'

Grant's frustrations in this respect seem short-lived, for he appears to take a businesslike approach to his craft while using materials which will ensure that his actual paintings will have a longevity far greater than the book-cover versions of them. Does he sell many of his paintings? 'I don't like to, but I've sold a few.' Assuming he doesn't suddenly find fame as a musician, it seems likely that his pictures will always be in demand.

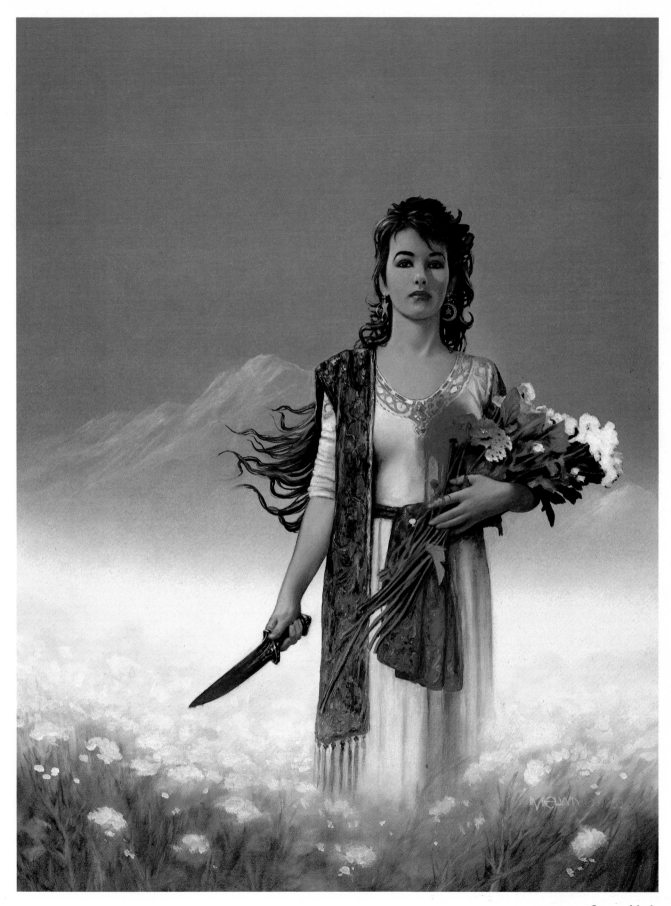

Queensblade.

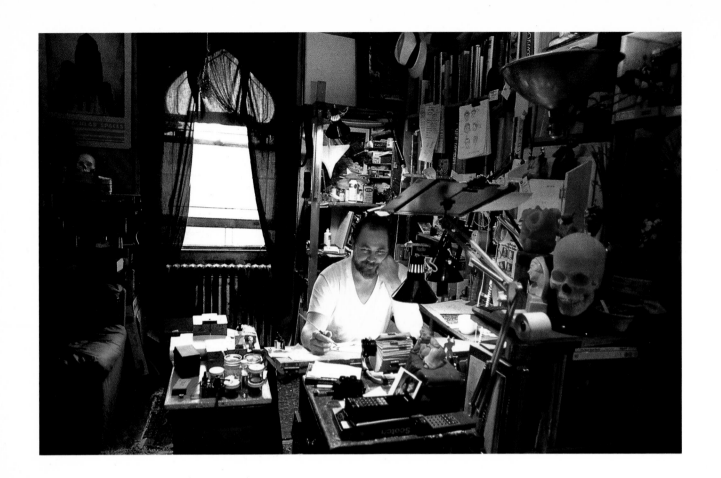

MICHAEL KALUTA

In the world of comic-book illustration, Michael William Kaluta is one of the best-known names. His style is distinctive and his list of credits impressive. Unlike many comics artists who are content to yoke themselves to a run-of-the-mill superhero or fantasy title, Kaluta has always chosen his work carefully, his art being no journeyman rendition of a script but something which shapes its whole mood and tone, as in his work on *The Shadow* and *Carson of Venus* in the 1970s.

Kaluta was born in Guatemala of Russian and American parents and later had an itinerant military childhood in various parts of the United States. Among his influences he mentions Toulouse-Lautrec, Klimt, Beardsley and the fantasy artists Roy Krenkel and Frank Frazetta. Many of his pictures positively swarm with detail and colour, reflecting an imagination that's bursting with imagery. But at the same time they're often carefully framed with borders and circles which impose formal constraints on their exuberance.

For the past several years, most of Kaluta's work has been on the graphic novel series *Starstruck*, published by Marvel. He finds it easy to draw and yet spends a lot of time on the pictures. *Starstruck* originally began as an 'off-off-Broadway' play, with two different productions in 1980 and 1982.

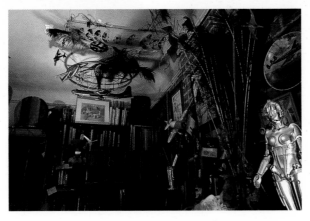

Michael Kaluta's studio, an Aladdin's cave.

Kaluta became involved when he was asked to do a poster for the show.

'It turned out to be an ensemble piece,' he recalls, 'a piece I fell in love with. I knew all the characters immediately just by reading about them. It was such a pastiche, poking fun at the comic-book genre. There was no single star to the show, and I felt that to do it justice I would have to draw every one of the characters on the poster, and they would have to be in costumes which I needed to design.'

He worked closely in collaboration with the writer, Elaine Lee. In the original play there were a dozen or so leading characters, only a small number of whom were featured in the original book based on the play. Later, as the graphic novel series developed, many other characters were added to the story.

Kaluta does his own colouring on the covers of each issue of *Starstruck* (pages 78,79), but the interior art is black and white, coloured by an overlay process. 'Doing my own colouring would be time-consuming and I'd feel as if I was doing the art all over again.' This has tended to make his style very focused on line-work, though lately he has been adopting the brush again.

Starstruck combines echoes of 1930s science-fiction films with a wide-eyed surrealism which

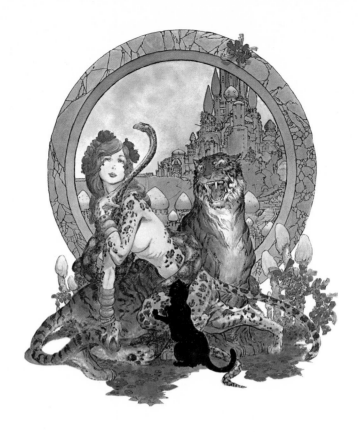

Children of the Twilight.

recalls both *Flash Gordon* and *Little Nemo*. 'The first time anyone mentioned *Little Nemo* in connection with my artwork, I was rather surprised because as far as I knew I hadn't studied *Little Nemo* to add it to my repertoire of imagery. But actually I had, simply by admiring it so much. It just comes out. It wasn't a conscious influence but a subconscious one. I'm not embarrassed by it.'

In the more science-fictional pictures, there seems to be a reluctance to include any kind of sleek modern technology; instead, more ornate and even rococo elements are used instead. Kaluta agrees, and it's plainly a conscious decision on his part since he finds the spare, angular forms of current architecture and design distinctly unappealing. 'I would like to think that once we get over the idea that functioning things have to look like boxes and get back to the romance of it, we'll see more window-dressing in the design of things. At the moment the window-dressing is horrible when it's added because it's based more on machines than people. I think eventually we'll get back to the romantic human need to look at something that is organic. I find that a lot more user-friendly.

'Some of the *Starstruck* pictures — like the one with the mermaid in it — are extremely organic (page 82). In the comic-book the rocket-ship that

70

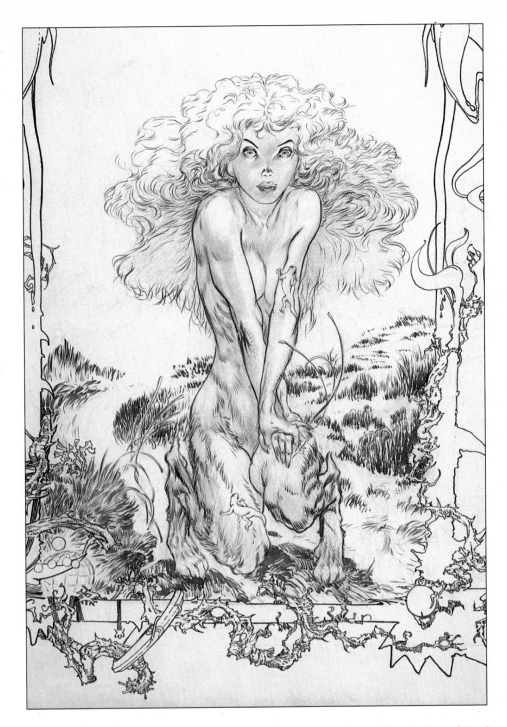

The Stealer of Souls.

the woman is captive on is actually made from living flesh so that it's a constantly undulating, warm, blood-flowing vessel — which is a kind of pun, I guess.'

Appropriately, Kaluta lives in a building in New York City which has baroque features. 'I can't say I chose to live in this area, but I'm vey happy I'm here. In this section of New York they're starting to tear down the buildings that have that look to them and put up the glass window-boxes that have

71

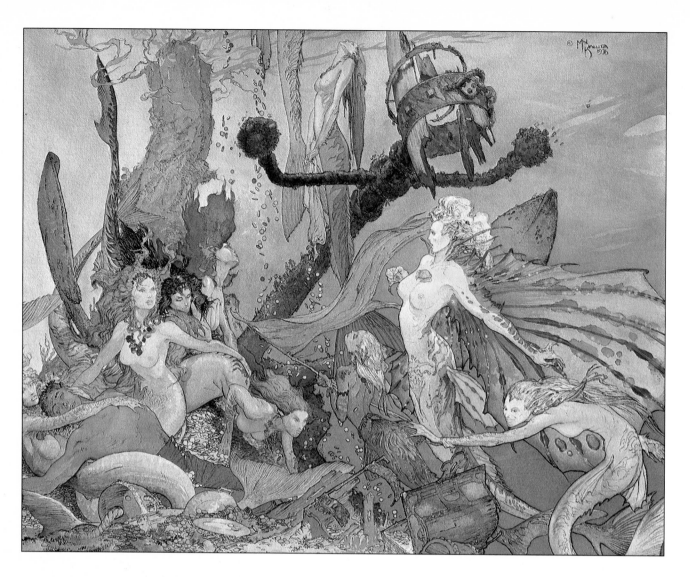

Behind Neptune's Throne.

a good view of the neighbourhood but no personality in themselves. As soon as I see one of the new buildings in New York I blot it out of my mind and try to put in its place what used to be there — a building which was probably lower and more mannerist.'

Kaluta's studio is a veritable Aladdin's cave of bizarre objects — skulls, globes, masks, and much else, cluttering a room with a window framed like something out of the *Arabian Nights*. It's a haven

of exoticism, turning its face against those aspects of the modern world which he dislikes. He pursues the archaic image, and feels he would only use present technology in a series of pictures if it were deliberately set in opposition to his own preferences. 'If there were to be individuals thriving in a modern setting, I would make that setting what people are used to now in the office with computers and suchlike.' But these would not be characters for whom Kaluta felt any special sympathy. 'As for

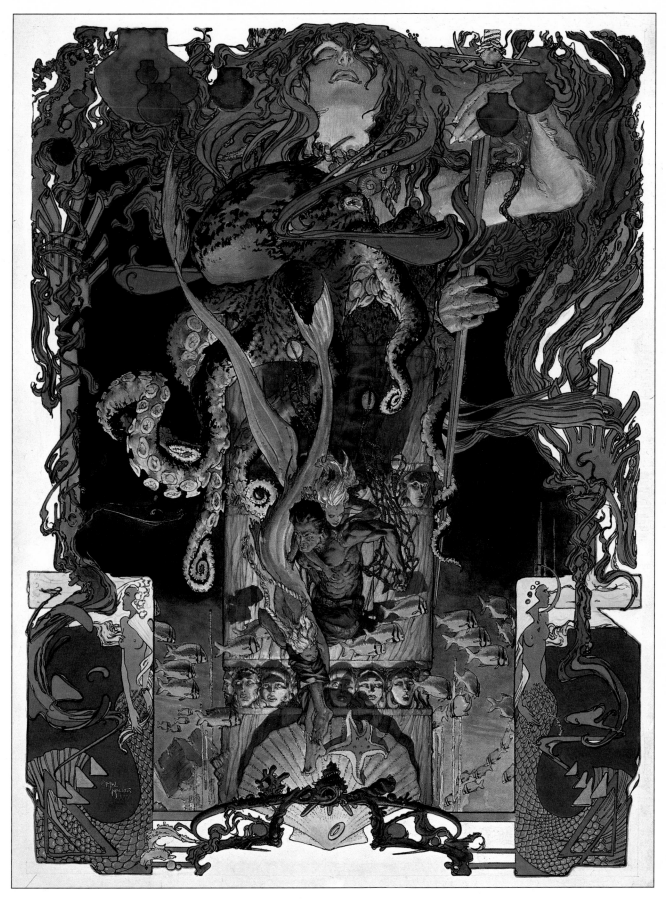

The Wedding Guest.

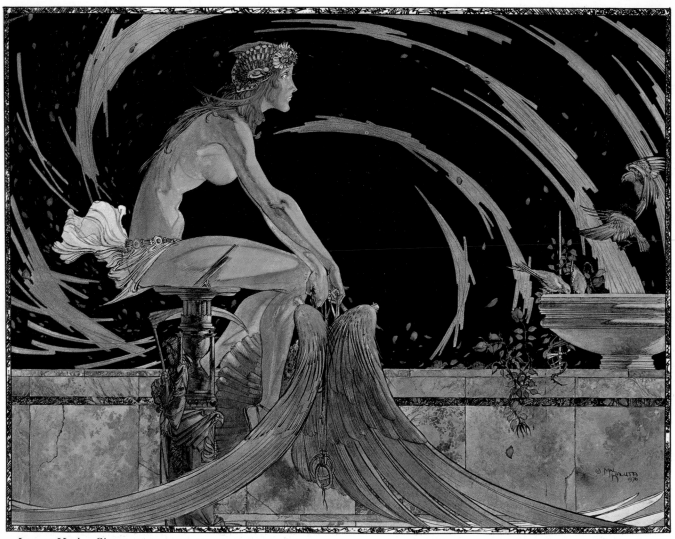

Icarus Had a Sister.

characters I like and whose lives I enjoy — I don't want to put them in that sort of setting because it's rather soulless. I want to put them in a place where there's lots of "hands-on".'

The graphic novel is a comparatively recent development in the comics world. What does he see as its appeal? 'It's the American version of what the French have been doing for years — the comic-book album. Often pieces that have appeared in different issues of a magazine are collected together until there's between seventy and 120 pages of a story, hopefully with a beginning, middle and end. It should read like a book as opposed to a comic book, which in the American terminology is a real quick throwaway item for the entertainment of children to take up a spare moment of their time between school and television. The graphic novel is something that's meant to be kept on a shelf, to be reread as you'd read Mark Twain. I'm not saying there's any correlation between *Starstruck* and

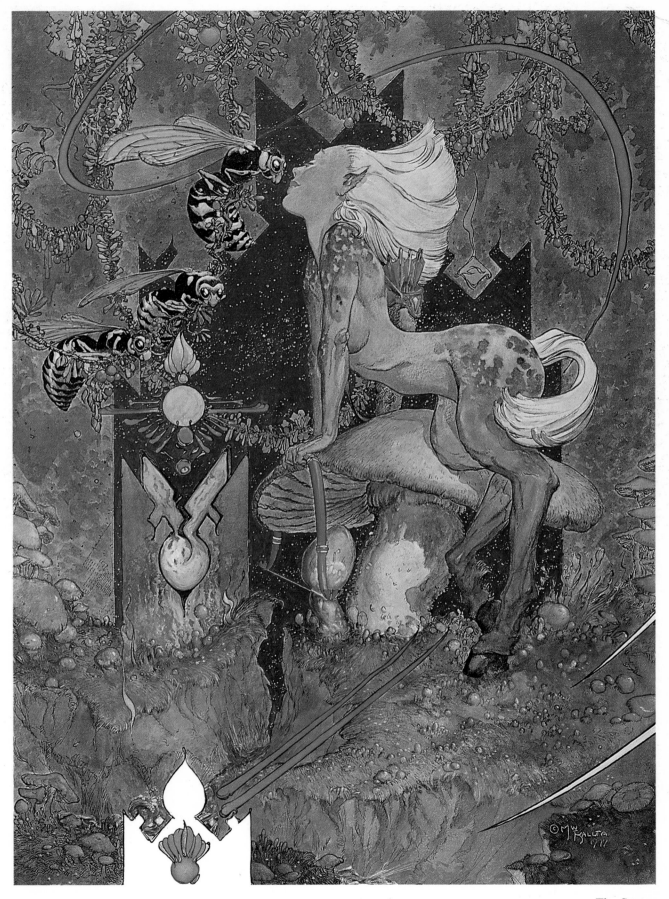

The Sentry.

75

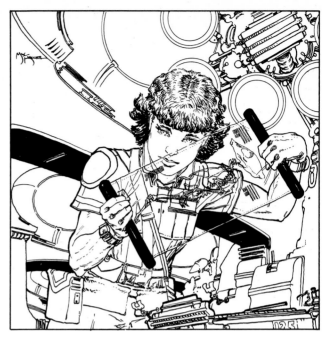

From The Legacy of Lehr, *by Kathrine Kurtz.*
Mather Seton and Wallis Hamilton.

Dr Shivan Shannon.

Mark Twain, except that I like them both!'

Kaluta's covers for *Starstruck* usually have a central picture framed inside a circle, a recurring motif in his art. It's a style which strongly recalls poster art. 'I've studied the poster approach and I like it. The target is often a circle — or if not a circle there's an implied target to the covers I do. I believe that it's the quickest way to get the information across. The target is the central focus in the picture.'

Much of Kaluta's earlier work was filled with exotic, often Middle-Eastern imagery. 'We know

why. It's because of all the *Arabian Nights* books I illustrated in the Seventies!' These days his figures tend to stand out more clearly from their backgrounds and the Arabian influence is more muted. 'I'm very happy when I can pull some of that old technique and concept back into the newer pictures. It makes me feel terrific that I have this backlog and it's not completely lost.'

One of Kaluta's more recent productions is an illustrated version of *Metropolis*. The project itself took twelve years to reach the book-publication stage, though Kaluta did all the artwork in a period

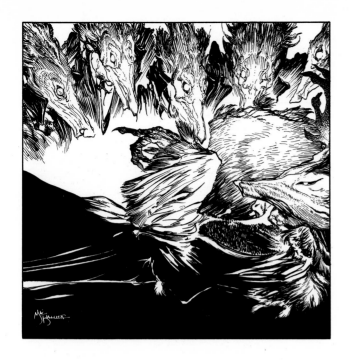

Muon's Trance.

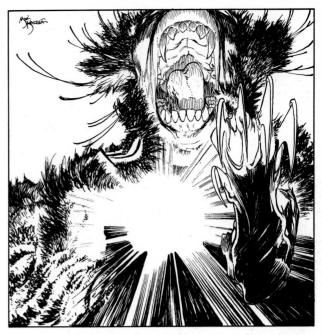

The Boolim.

amounting to three months of intensive work. It fulfilled a long-standing ambition of his. He talks of how, when Fritz Lang first came to the United States, he stood on his ship, viewing the glittering nighttime skyline of New York City with a wonder that later became a major source of inspiration for his celebrated film. To Lang, the scene must have been futuristic and fantastic, qualities which his movie conjures up in every frame. In Kaluta's case, however, the inspiration for the *Metropolis* pictures came from a slightly different source.

'When I was a child, a paperback company

published *Metropolis*, and on the back of the book it said, ''This is the best science-fiction novel ever written and the best science-fiction novel ever filmed.'' I loved the book, but in those days I couldn't draw. But I thought that if I ever did learn to draw, I would want to illustrate the book. Later, when I was in college, I saw the movie. It was totally wonderful, but not the same as the book — there wasn't enough of it. Fritz Lang had apparently filmed the entire book, but this made a three-hour movie, which was cut down to about one and a half hours. Since its release, pieces of the movie

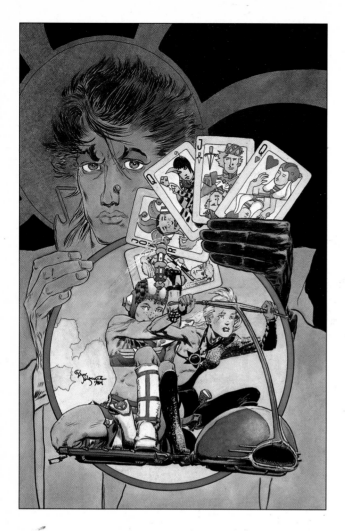

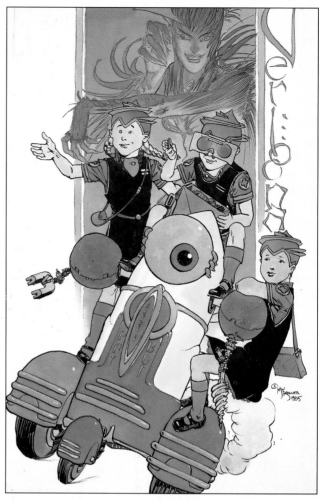

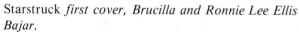

Starstruck *first cover, Brucilla and Ronnie Lee Ellis Bajar.*

Starstruck *third cover, The Girl Guides and Verloona.*

that were cut have gone missing. They've tried to put the whole thing back together, but they've never succeeded.

'The book is still in one piece, but few people know that the film comes from a classic novel. So I thought that if I could get the opportunity to illustrate *Metropolis*, people would know it's the *Metropolis* of the movie, but they'd also be able to read the words of Thea von Harbou, who not only wrote the book but was the screenwriter for the

movie. Then I would have succeeded in one of my youthful dreams. So it has come to pass.'

Kaluta admits he was somewhat daunted by the project, even though he was inspired by the film as soon as he saw it. He took pains to portray the New York which is contemporary to the novel as opposed to today's city. Conscious that he would be reinterpreting imagery which was already standardized in many people's minds through seeing the film, he managed to create his own style while

Starstruck *second cover, Harry Palmer.*

making references to the cinematic version. 'It was difficult — especially with the female robot. The one in the film has never been topped — even C3PO in *Star Wars* doesn't top it. Trying to come up with a robot face that echoed the *Metropolis* robot in the film without copying it was a real challenge.

'These days the Japanese are the masters at imaging robots — the chrome of the feminine robot which of course is again based on the *Metropolis*

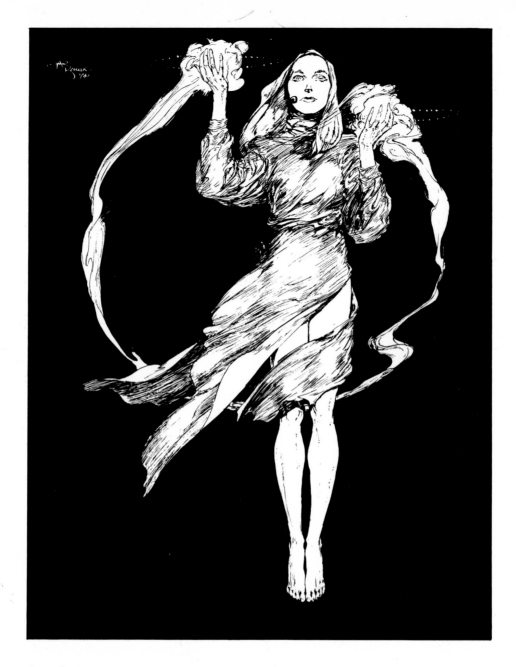

Starstruck, *Bronwyn of the Veil.*

robot, but highly articulated and highly reflective and obviously sexy from a male standpoint. As machines they have articulated sexual movements — and *only* articulated sexual movements.'

One of the book's most striking images is a 'targetted' picture of the female robot's hand (page 87), which was used on the back cover of the hardback. 'The hand came much easier than drawing the face of the robot. I had several different faces. The appealing image of the book and the

movie is that there is this robot who has turned into a woman. So I tried to develop a strong robot-face which would convey this feeling. I wasn't getting it, so the hand came out instead. For years I'd been drawing it in my sketchbook — a steel and platinum and glass articulated hand. In the book she was made out of platinum and covered with a glass-like substance. In the book she is transparent — you can see everything working inside her, which I think is a pretty fantastic image. One of the things

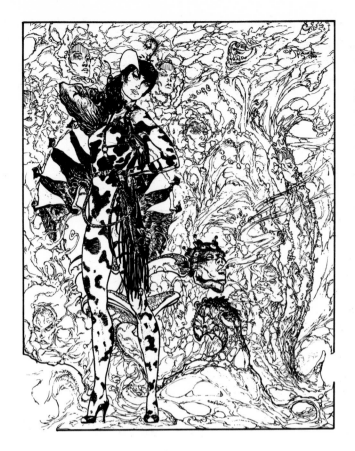

Starstruck, *Galatia 9.*

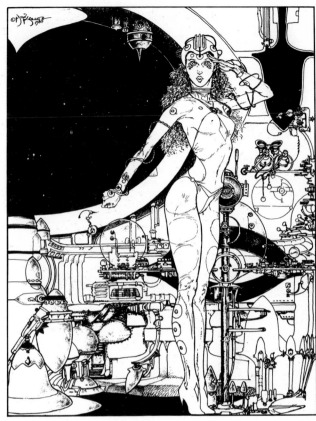

Starstruck, *Erotica Ann a pleasure droid.*

I wasn't able to do in the illustrations was to convey this transparency. I tried to capture it, but I haven't managed it yet.'

Was it a shock to the system to return to full-colour art after many years doing mostly pen-and-ink work? 'No. It was a completely freeing event.' The actual illustrations were considerably reduced for printing in the book, the smaller pictures originally being 9 inches by 15 inches, the larger charcoal pieces over twice that size. Though he did not have any direct say in the overall design of the book, Kaluta is pleased with the end result.

The illustrations in *Metropolis* are coloured with pencils, wax crayons and gouache, not the sort of media Kaluta normally uses. Sometimes he's playfully inventive in his choice of materials, as in the illustration of the nude woman backdropped by a skeleton (page 87). 'It's pencil and red wine — mulled wine that was a gift at Christmas. The flesh tones are coffee and tea.' For the yellow highlights,

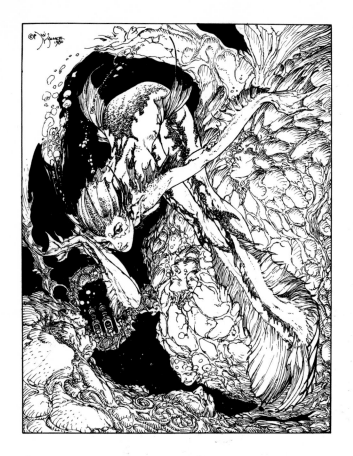

Starstruck, *EEEEEEEEEELUH*.

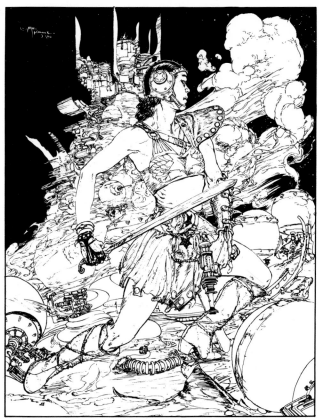

Starstruck, *Brucilla the Muscle*.

he reverted to the more traditional watercolour. 'I tried scotch, but it's too subtle — it just disappears.'

The balance of muted colours and pencil drawings works very well. Why did he decide on such a subtle colour scheme for many of the pictures? 'They're illustrations in a book as opposed to single-image poster work. I didn't want the work to overpower the writing, and if I put the kind of colours I'm used to putting on my work, I believed

it would. Previous books that I've illustrated have been very purple in that sense. Heroic fantasy can take full, rich, out-of-the-tube colour, but not this one. Having some pencil and watercolour illustrations meant that there was not the next day's long step of lining all the pencil with ink. Often solidifying the image takes out all the ambiguity that pencil sometimes gives.'

How does he feel a piece of artwork after he's finished it? Is it an end in itself? Is he concerned

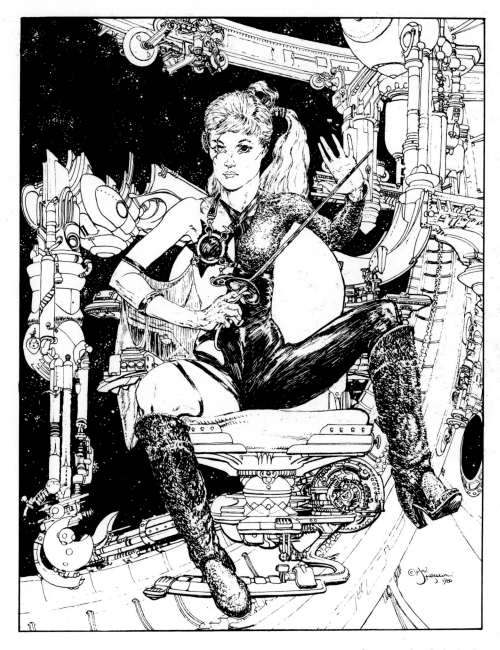

Starstruck, *Galatia 9*.

with its longevity? 'I think about it while I'm doing it, but I don't paint with media which I know will last forever. I paint with what I feel comfortable with. I do know artists who've changed their media when they've discovered that the paints they're working with will not last more than 75 years or so, but I'm not one of them. The colours on some of my pieces are done with Dr Martin's aniline dyes, which are supposed to be incredibly fugitive. But I have yet to see any of my pictures fade.' Similarly,

he is not concerned to work on acid-free paper.

He does, however, keep the originals of much of his work. 'I've sold a fair percentage of it, but I continue to hold the larger originals, the more signature-type pieces. Sometimes I do wonder what good it's doing sitting in a portfolio here in my room rather than hanging on someone else's wall in the real world. Or you get the paranoid thought that every major artist has had a fire in his studio at some point.'

83

Starstruck, *pages from no. 1.*

One of his more recent illustrations is a pencil-and-ink rendition of a wolf-girl with two salamanders (page 71). 'There'll be some hint of watercolour in there when it's finished. It's for the cover of a book of my sketches which also includes a checklist of my work.' He enjoys the idea of producing a portfolio of his art, irrespective of whether it proves to be a commercial proposition in the sense that it makes him money. 'It's a freeing kind of job because you're not advertising anything except your own imagination.'

Has he branched out into other forms of design apart from illustrations? 'Every once in a while I'm tossed a job to design something like a rocket-ship or some characters for a television commercial.' He sees such commissions as very much a sideshow to his main illustrative concerns. When he has a very open brief, he resorts to his sketchbook. 'I use it to put down thoughts from my head as opposed to thoughts for a specific job.'

Kaluta regularly attends science-fiction and comic-book conventions, where he can mingle with fellow professionals and fans of his work. For him, such conventions are more a social event than a commercial one. 'You don't make money at conventions, but they're important to me. One of the main reasons why I concentrate on comic-book art rather than sf book jacket covers is that there's a

Starstruck, *pages from no. 1.*

much greater honouring of comic-book artists than paperback ones. I like for people to respond to the work I do, to have conversations with people which arise from an image pulled out of my head. I do need an audience, because my pictures would mean nothing just sitting in a room. I'm one of those people who does enjoy and admire my own work. I have a relationship with the work, as opposed to seeing it in a strict commercial sense in which one would be aware of one's technique and aware that one could meet the parameters of the job, but have no emotional tie with the work. I'm highly tied to my pictures.'

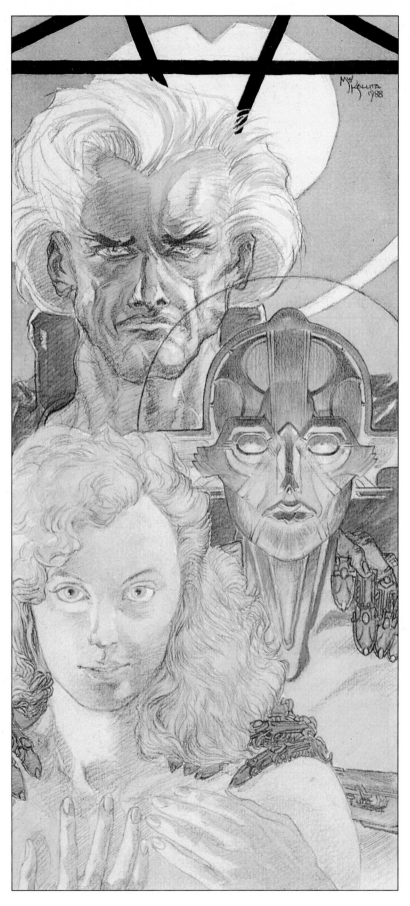

Metropolis, *Maria, Futura and Rotwang the inventor*.

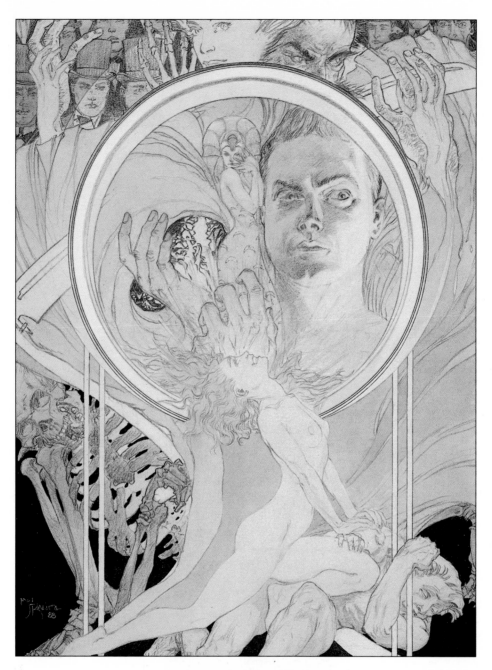

Metropolis, *Freder's dream*.

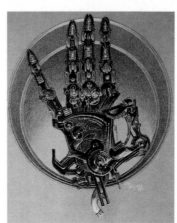

Metropolis, *The hand of Parody (Futura)*.

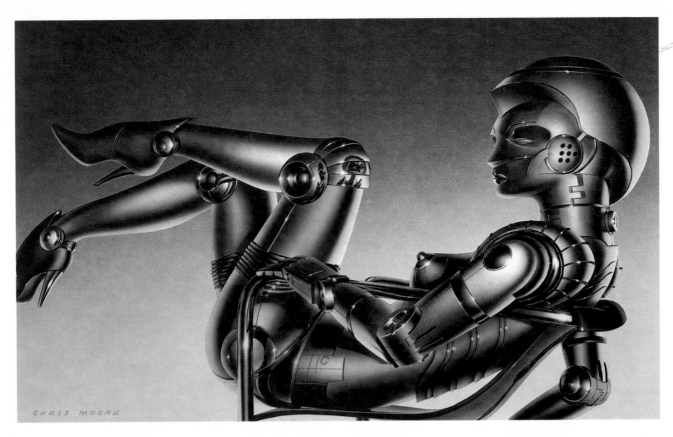

Higher Tech.

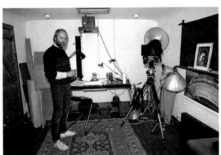

CHRIS MOORE

Fantasy and science-fiction art has come of age — at least in the sense that its icons are no longer restricted to a coterie of fans and readers but now have a place in the daily lives of everyone. Its imagery has evolved rapidly over the last few decades from the comic-strip and often comical drawings of submarine-type spaceships, bug-eyed monsters and rough-hewed heroes into almost photographic renditions of massive starships, biologically plausible aliens and animals, and heroes and heroines who are often the perfect paragons of humanity. The illustrations are smooth and slick and convincing, invented objects given a complete appearance of life in a two-dimensional context. But above all, fantasy art has discovered a sense of scope and panorama. Its characters and artefacts now inhabit

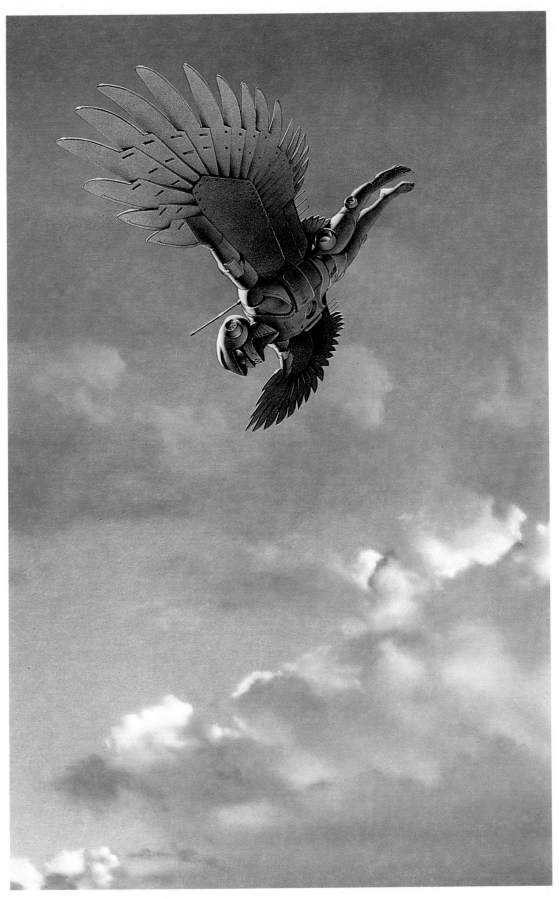

Trillion Year Spree.

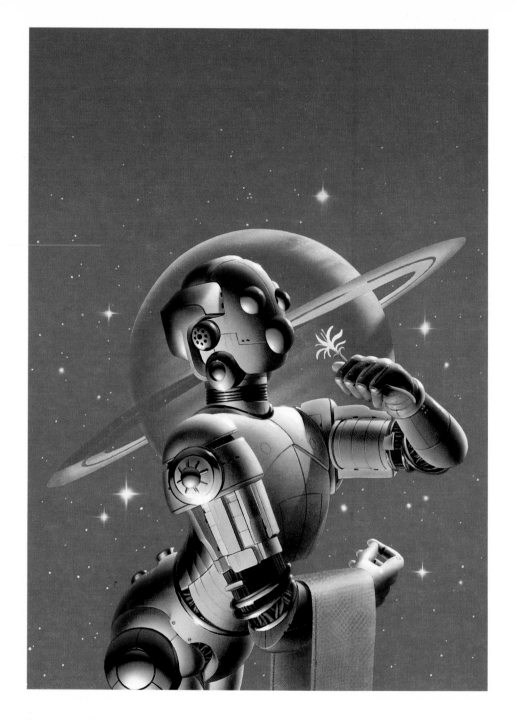

Special Deliverance.

sweeping landscapes and the vast reaches of space so that we have the sense of whole worlds and whole universes opening up before us.

In Britain, this shift in perspective from the closely focused to the telescopic can be chiefly attributed to the artist Chris Foss, who in the 1970s began producing a whole series of pictures fea- turing massive craggy starships backdropped by the immensities of space or the enormous curving hori- zons of planets. Foss's covers, which proved very popular, opened the way for many other artists to bring their own wide-canvas visions to an audience which was now eager for such things. Among the best of these artists was Chris Moore.

The Proud Robot.

Moore's spacecraft are as large as Foss's, and they occupy equally spectacular vistas of space and sky. However, where Foss's ships were bulky, angular things of improbable construction, Moore's were always curvaceous and aerodynamic. No matter how monstrous, they conveyed a feeling of having been designed rather than thrown to-gether. Foss's spaceships, for all their bizarre rectilinear splendour, are the products of a dreamer's imagination, whereas Moore's arise from a mind that has a similar boldness, but is tempered by an adherence to sound engineering principles. One can almost imagine that many of his craft already exist at the design stage on draw-

Crackerjack.

Catface.

ing boards somewhere in the real world.

Moore admits an interest in space and space travel, and his concern for plausibility shows in most of his paintings. Whereas other artists might show outer space in lurid shades of red or green for dramatic effect, Moore tends to stick to black. Not for him an impossible conglomeration of moons and ringed planets in a sky. This is not to suggest that his images are sober or pedestrian. Far from it: they have a grace and a splendour which seems to arise from the very constraints placed on their execution. The imagination is disciplined but never dull. His spaceships sometimes soar out of the corners of his pictures, echoing the opening scene in the film *Star Wars*, where the ship carrying Princess Leia emerges with a thundering roar out of the top of the screen until it almost fills it entirely. But whether borrowed or invented, the images have a freshness of their own which derives from Moore's excellent craftsmanship and the integrity

of his imagination.

No doubt all this would seem grandiose to Moore himself. Although he is perhaps known as a science-fiction artist, he has always done a variety of other art and claims that his sf pictures never represented more than about thirty per cent of his output. He is laconic and completely lacking in pretensions with regard to his own work, seeing himself very much as a commercial illustrator who does pictures to order.

'First and foremost, I believe that I'm doing a job. I'm being paid to produce something that somebody wants. That is the nub of the whole thing with what I do. On top of that, if for some reason there is an intrinsic value in a painting that people recognize, that makes them want to hang it on their wall or see as being art and something they want to cherish — then that's a bonus. It's not necessarily something that was an integral part of it in the first place, that was designed to be in there. I don't

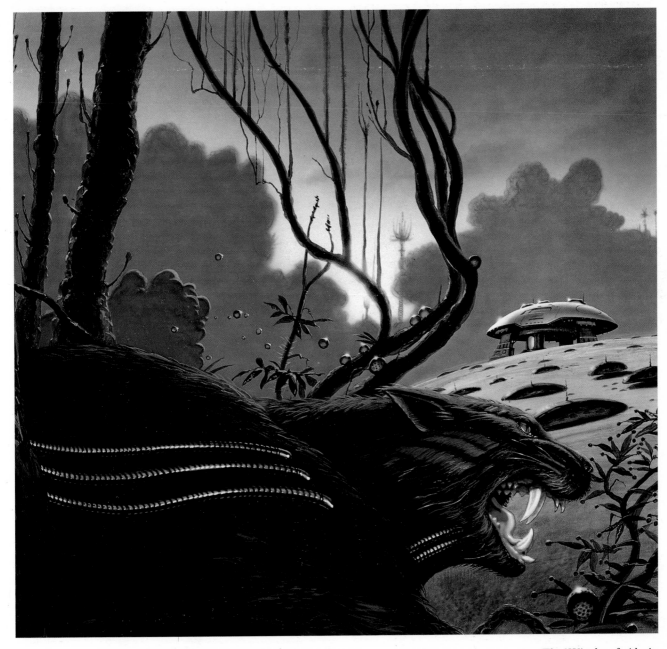

The Winds of Altair.

produce my pictures for people to hang on their walls.' At present Moore appears to divide his time between doing cover-art for publishers and illustrations for advertising agencies. The advertising work comes through his agents, whereas he gets his publishing commissions direct, a measure of his reputation in the field as a cover artist.

Considering his work as a whole, it becomes abundantly clear that he is a far more versatile artist than perhaps his purely science-fictional illustrations would suggest. And because he takes such a pragmatic approach towards his work, it's difficult to pinpoint themes or stylistic motifs in his work. Looking at his panoramic sf pictures, one might be tempted to assume that he does not like drawing the human form, since figures are often

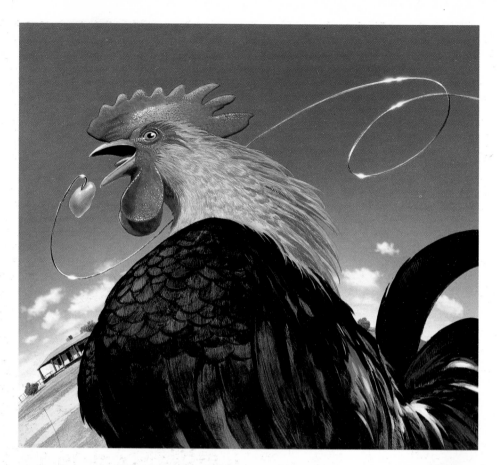

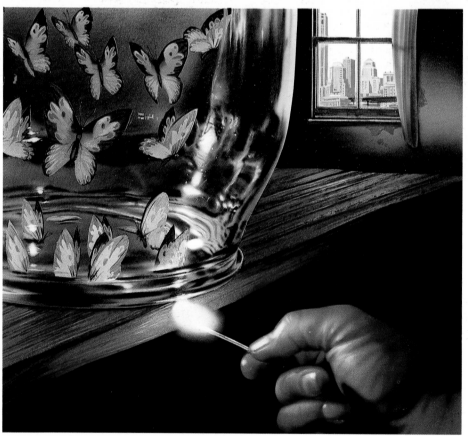

Chicken Fishing, from The All-Girl Football Team. *Vintage Books, New York.*

Steps. 94

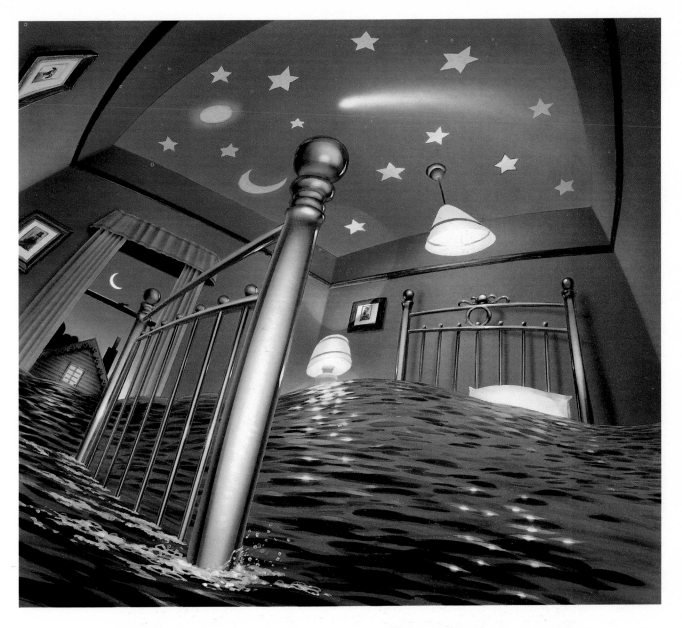

Ellen Foster, Vintage Books, New York.

small or entirely absent in such pictures. Yet other illustrations show him perfectly at ease with figure work, and he once executed a whole series of robot illustrations whose shapes are affectionate parodies of real people. Did these reflect some private obsession?

'Somebody asked me to do them, that's all. Having been successful the first time, people came along and said, "Can you do something for us along the same lines and in the same vein." And that's the way it's built up. I started doing science-fiction paintings because somebody asked me to do science-fiction paintings.'

Perhaps the only single unifying thread in all of Moore's work is a concern for quality and the direction of the light that falls on the objects in his paintings. Even though the Sun may not actually be visible in a picture, it's always possible to tell where it is by the light which gleams along the flank of a spacecraft or the way the shadows lie. Even in his

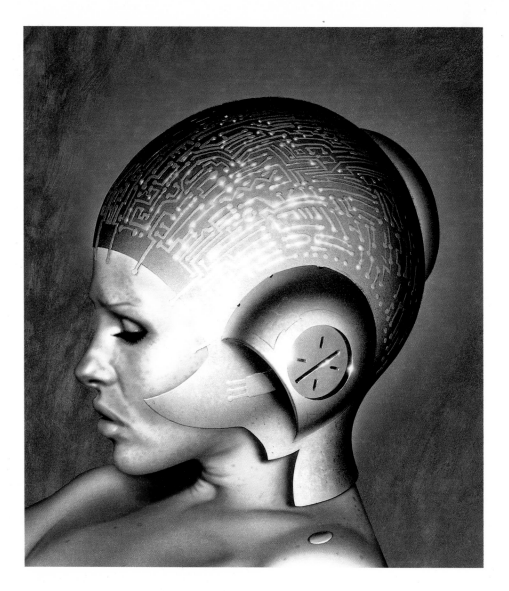

Burning Chrome.

robot pictures, some of which feature indoor backgrounds, the metal skins glow with highlights from unseen sources of illumination. And because shadows are longer and the light more mellow at dawn and dusk, many of the pictures have a twilight atmosphere to them, with the Sun just peeking over the rim of a planet, colouring the sky and the land all shades from gold to red-brown. And in pictures featuring full daylight, Moore usually finds a way of introducing shade by having cliffs, caverns or buildings where the sunlight cannot penetrate fully.

Sometimes he will make models to assist in the process of visualization. The actual content of the illustration is very much conditioned by the requirements of the customer. 'The brief that you get determines the parameters you work within and determines the way the thing comes out. All you're doing is assimilating what you've been told into something that fits the bill.'

Some of the more successful and popular British cover artists are often taken up by American publishers, and Moore has recently executed a number of cover paintings for a prestige series of paper-

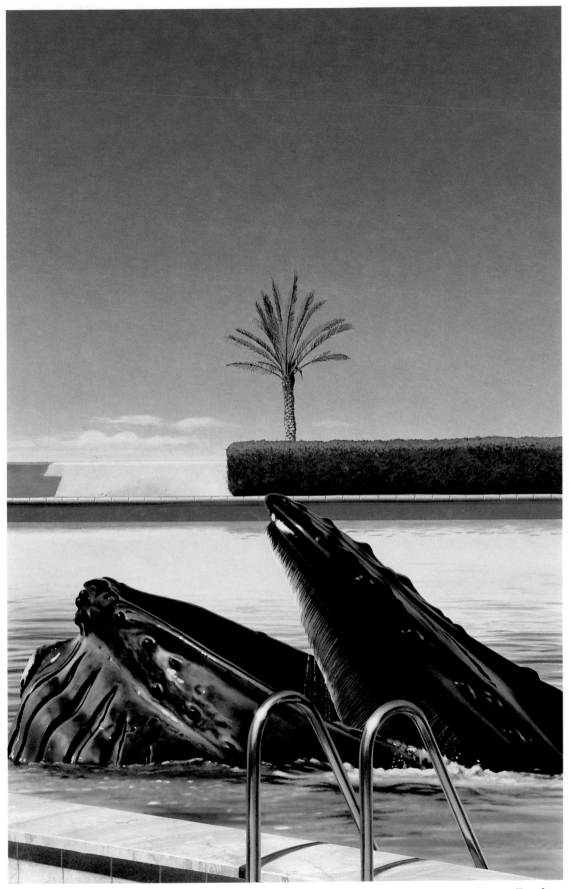

Far from Home.

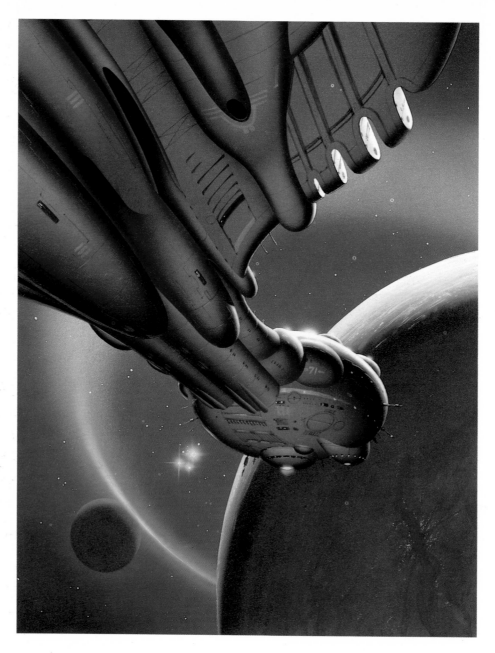

Leviathon.

backs published by Vintage Books in New York. Because the American market is larger, the work is better paid, but Moore finds that US publishers are often harder to please.

'They tend not to settle for the first idea. At first I thought it was because it's a different culture and I'm not really on the same wavelength so that what they want from you is not what you're used to producing. The way it works over there, the art directors are very much controlled by editorial influence.' Covers have to be submitted for editorial approval, and this is not always readily given.

Moore's cover from the book *Ellen Foster* by Kaye Gibbons (page 95) was finally produced only after four earlier roughs had been rejected on various grounds. The first rough featured a black girl and a white girl holding hands outside a ramshackle house. This was returned on the grounds that the publishers wanted something of a more fantastical nature. The second one more closely resembled the

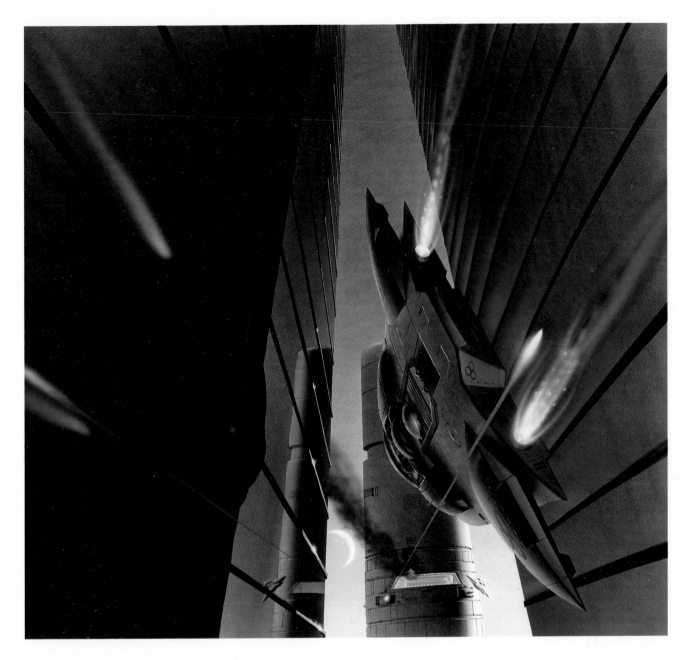

City Street Fight.

finished artwork, but when the publishers asked for changes, Moore produced a completely different sketch which was rejected with the request that he return to the idea of the bed awash with the sea. After further modifications which involved bringing the bed more into the foreground of the picture so that the perspective would be even more exaggerated and distorted, it was finally accepted and the finished art could be done.

Moore does his roughs on tracing paper, sending

off a photostat to the publishers when working for an overseas market. Though he admits to being selective, he does try to read the books he illustrates where possible. 'I think it's very important. I always try to produce something which is actually right for the book.'

The cover art for the Vintage Books series tends to have a surrealistic flavour. The *Ellen Foster* picture derives from a scene in the book where a girl is sitting in her grandmother's bedroom while

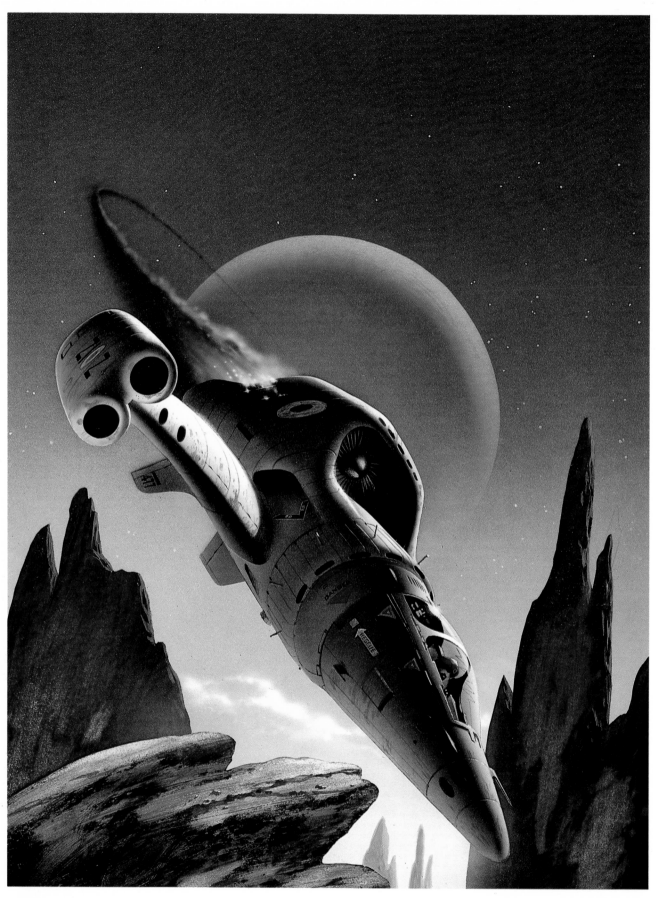

Nosedive.

Sum VII.

the old woman is dying in bed. 'She looks out the window, and then she looks at the bed, and the folds in the bedclothes remind her of the sea.' For *Steps* by Jerzy Kosinski (page 94), the image was suggested by the publishers. 'The characters in the book were in the ruins of a city. There was this abundance of butterflies, and they would catch them in a jar, then hold a lighted match under the edge of the jar so that it filled with smoke and all the butterflies died. There's a strong analogy between that and the gas chambers.' For a short story collection, *The All-Girl Football Team* (page 94), Moore chose to illustrate a story called 'Chicken

Fishing'. 'There's this kid in it who wins a fishing rod in a lottery and goes fishing for chickens in the yard. There's a big cockerel in the yard that he's terrified of.' Again, a distorted perspective is used in this picture so that it takes on fantastical qualities. Whether prompted by the publishers or not, it seems fair to suggest that Moore will always favour bizarre or fanciful rather than mundane imagery.

The Vintage pictures were reproduced four inches square on the covers of the books. Moore's original art was double this size, and he generally tends to work twice up. He uses both brush and airbrush, acrylics and shellac-based inks. 'I find the

101

Islands in the Net.

hardest part about what I do is steeling myself to do it, working up the enthusiasm. There's always something to distract you. I can be working on something — looking for something that might give me a bit of an idea of how the light might fall on it, say—and something else will catch my eye and I'll be off — thumbing through a book for an hour, drinking coffee, and all the while I know that there's this deadline that I've got to meet. It's almost as if there's a subconscious clock inside me ticking away that knows exactly how long it's going to take and when the thing's got to be in. And when the two get together, when my back's against the

wall and I know I've got to produce it, then I go and do it. But up until that moment comes, I'll do anything else. Having said that, all the other illustrators I know well — they're all the same. They would rather be out in the garden if it's a nice day.'

Moore lives and works in Kent. Despite his seeming reluctance actually to produce his illustrations, he's very prolific, though he expresses surprise when described as such. He always tries to get his original artwork returned after it's been used, and then promptly stores the pictures away in a cupboard in his studio. How many has he got? 'I

Alpha Bug.

Exiles.

don't know.' Has he ever put any of them in an exhibition? 'No. I've never done anything like that. Everything I get back ends up in here.'

Moore's matter-of-fact attitude towards his art is refreshing, the more so because of his undoubted qualities as an illustrator. And it doesn't mean that his approach is any less dedicated and thoughtful than artists with loftier aspirations. Recently he gave a lecture to school teachers on identifying and solving problems, and some of his comments are clearly applicable to his art. 'Once you understand where the problem is, you've got the solution. It's

the thinking process that is important. You don't start writing a story out of a vacuum. You don't start typing and hope that something will happen. You've got to know what you want to do before you start doing it.'

How does he see a finished book cover in relation to the original picture which he produced? 'It's one stage removed from a painting because it's a printed thing and it's got that gloss about it. Somebody in a bookshop sees what after all is an image with type on it and information, communicating an idea — and they buy it. That's what it's about, and

Way Station.

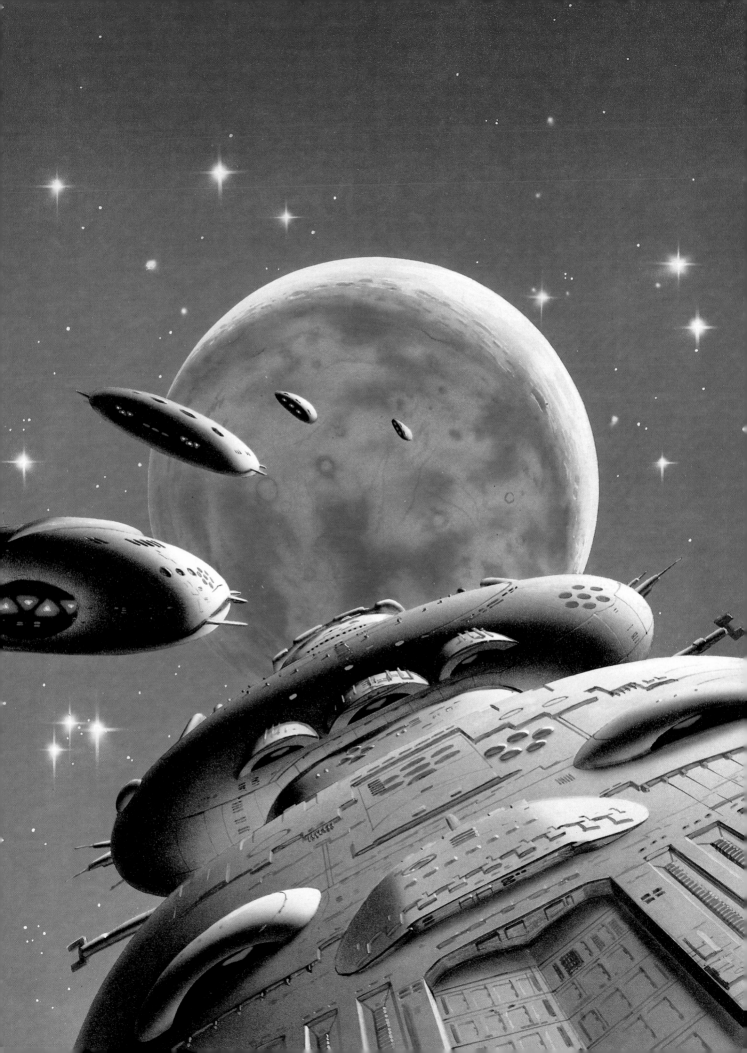

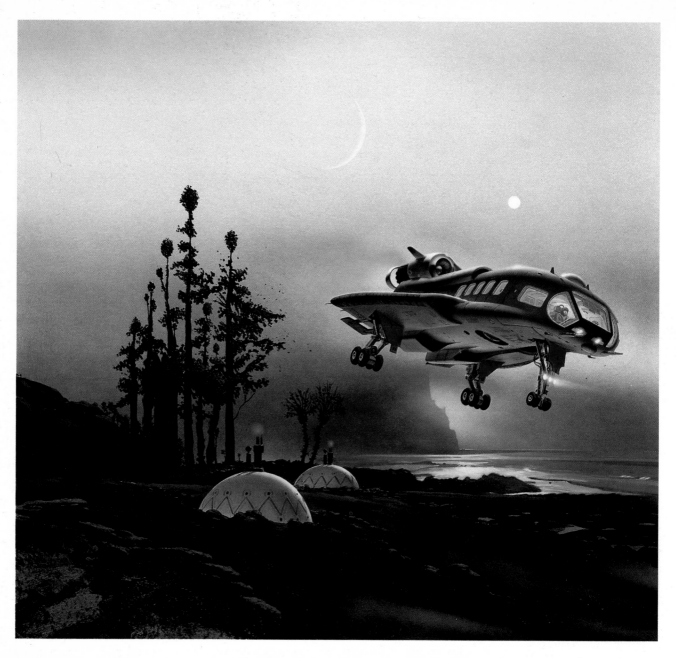

The Legacy of Herorot.

that's what I'm in the business of.'

Moore is not possessive about his art, and indeed regards it as something almost distinct from himself. 'When looking at the things I've produced, it's almost as if somebody else has done them. I don't identify with them. I don't actually feel as if I've done them. I feel like I've been a party to it but it's been done by somebody else almost.

'My mother once said that I have a tendency to be a bit boastful about my work. All I can say is that it's like a child who's found something and thinks, "That's great!" It's like it happens of its own accord. Don't print any of this, will you — it's total crap really.'

Ringworld.

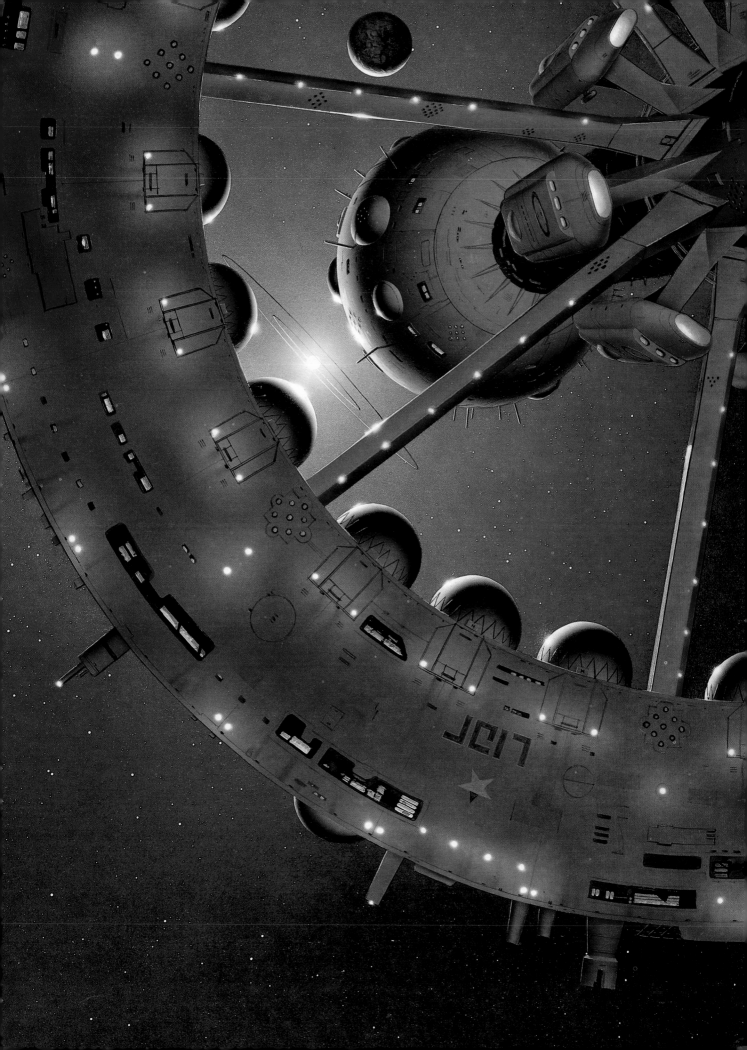

BERNI WRIGHTSON

In 1979 Berni Wrightson had a handsome retrospective volume of his work published entitled *A Look Back*. It was scarcely ten years since his illustrations began appearing professionally, and it's a measure of his abilities that in such a short time he should have made his name as one of the foremost exponents of the art of the macabre.

The bulk of Wrightson's work is pen-and-ink drawings, and most of it has appeared in comic books. He began working for DC (National Periodicals, the publishers of *Superman*) in the late 1960s, finding a niche in horror titles such as *The House of Mystery* and *The House of Secrets*. Along with Michael Kaluta, Barry Smith, Neal Adams and others, Wrightson was part of a new breed of comic artists who brought a refreshing and striking sense

of personal style to a medium that had hitherto largely relied on journeyman artwork. They succeeded in transforming reader's expectations of what comics could achieve, and issues featuring their work are highly prized by today's collectors.

Wrightson was born in Baltimore City in 1948. He remembers clearly one of the chief sources of inspiration for his art. 'My interest in Gothic horror goes back to early childhood. When I was very little the EC horror comics were appearing on news-stands all over America in the early to mid 1950s.

'There was a corner candy store when I was a kid, and one entire wall was a comic-book rack, covered with comics of all kinds — superhero, funny animals, horror comics, all mixed together.

Berni Wrightson's studio.

I would go in and pick out the horror comics. For two cents, you could rent a comic book. You could read it, then put it back on the stand. So with a dime, instead of buying one comic book, you could read five. It was a great deal. They had little seats in the room where all the kids in the neighbourhood could come in. It was a kind of a baby-sitting service.'

Wrightson's mother did not approve of the comics he did bring home, and would take them away from him and tear them up. Wrightson never mentioned to either of his parents three nocturnal encounters with a headless woman who came into his bedroom and rummaged through drawers in the house where they lived until he was about seven years old. Though he claims not to believe in ghosts, he remains convinced to this day that the experiences were not dreams.

His parents were of Polish extraction, and he was educated in strict Catholic schools, another factor which he feels predisposed him to horror. His interest in art was stimulated by a Saturday morning TV show which offered elementary instruction on drawing techniques. Later he took a correspondence course which his parents financed. It remains the only formal art training he ever undertook.

Wrightson began publishing some of his earliest drawings in fanzines — amateur publications usually produced by comics fans. In all his work the modern world is conspicuous by its absence, the pictures harkening back to the eighteenth or nineteenth centuries, or even earlier. Monumental

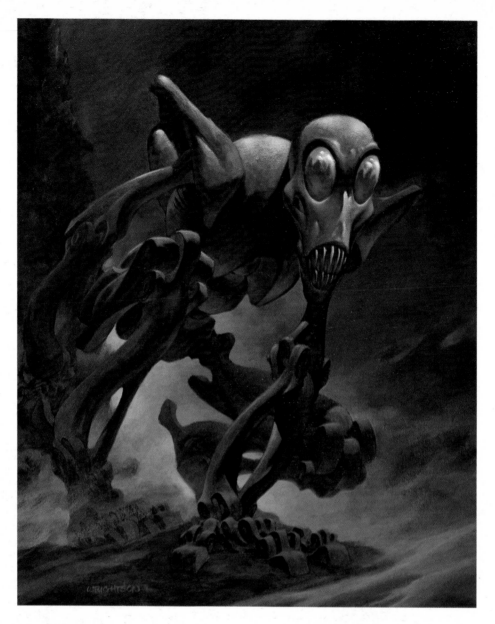

Metal Man.

gravestones, gabled mansions, ornate Gothic Revival furniture, elaborate chandeliers, drapes and guttering candles — all are typical architectural features of his work. His landscapes frequently feature twisted trees, craggy hills and distant mountains, tangled grass whose every blade stands out sharp and distinct. They are worlds in which the darkest fears and superstitions of the human race have become real, worlds haunted by ghouls and madmen, worlds where a rational scientific outlook stands for nothing.

Most of Wrightson's pictures have a narrative feel, a sense of being a still from an ongoing story. They also have a statuesque quality, the action or terror being frozen in one moment so that the viewer is compelled to dwell on the often grisly details. The thrill one often gets from his pictures arises out of the fearful anticipation of what is going to happen next, and it's not surprising that they are so successful, given that true terror resides

Loggerhead.

110

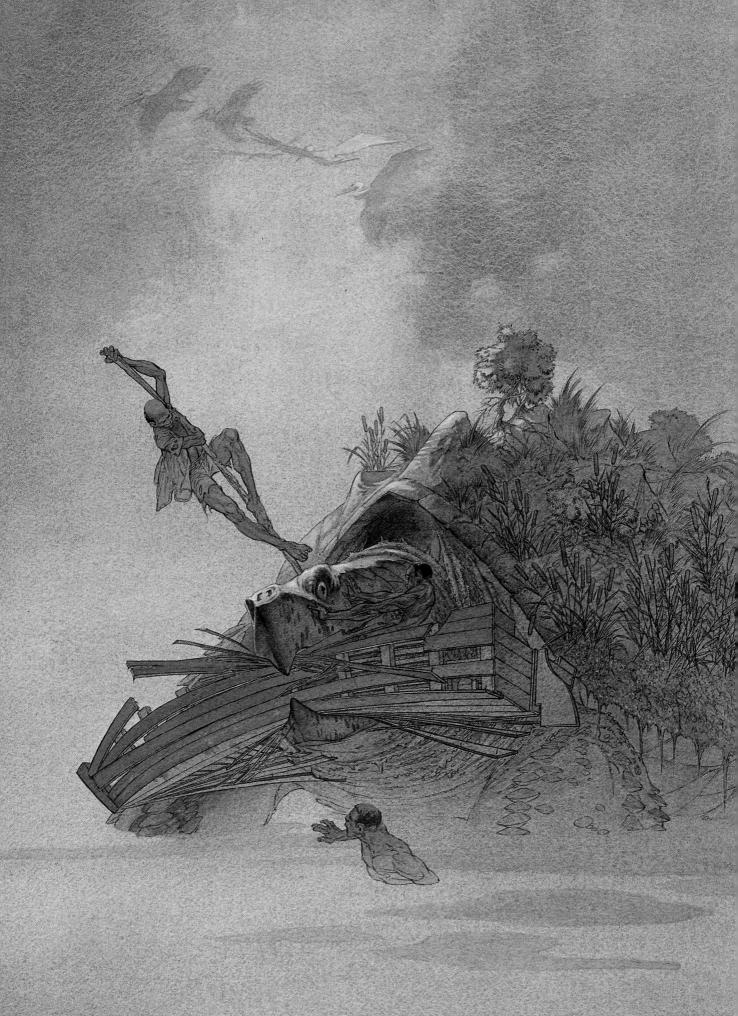

Pages from Captain Stern *comic book.*

in the *expectation* of something nasty rather than the actual fact of it.

Given the brooding and often gruesome nature of much of his art, it's perhaps somewhat surprising to discover that in real life, Wrightson is an articulate and engaging individual who sees his art as *fun*. 'I hope nobody is getting seriously scared by my stuff because I don't mean to seriously scare or warp anybody. Really it's all a bad joke. I giggle at the stuff as I'm doing it.'

So what does he see as the appeal of such art? 'I think everybody would like to encapsulate their own fears. You put a face on it and you personalize it. That's why horror comics, stories and movies are so popular. Whatever your particular fears happen to be, they reduce it to a size that you can cope with.'

Wrightson's own art begins with pencil drawings which are then inked over and the pencil rubbed out. Does he regret the loss of the initial pencil sketch? 'It's unavoidable. I can't think of any better way of doing it.' With comic-book work in particular, he's less attached to the initial sketches. 'I don't feel any remorse for a pencil drawing that was done for the purpose of being inked because it's not to my mind the same as a pencil drawing

Page from Captain Stern *comic book.*

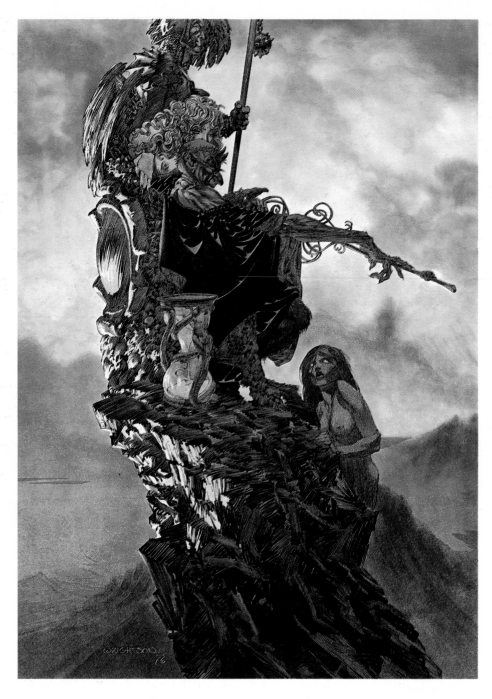

Counsel to a Minion.

done solely to exist as a pencil drawing, where you can use tone and work with the side of the pencil to create broad strokes of grey and grading from dark to light. The pencil drawing for pen-and-ink work is preparing the drawing for the picture to be inked.'

At present, Wrightson on a *Batman* comic book

for DC. He sends copies of the inked artwork in to the publishers to be coloured before printing. 'Sometimes I do my own colouring, but it's mostly a question of time. If it's something I'm creating totally — if I'm writing it and starting from scratch, then I would prefer to colour it myself because the colour is an integral part of the whole

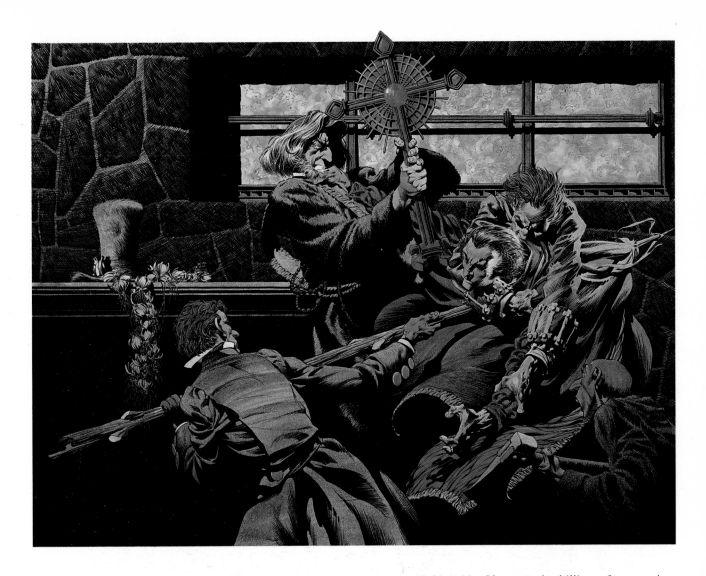

Taking No Chances, the killing of a vampire.

process. But if I'm working with a writer, it becomes more commercial then. A character like Batman is owned by a company, and while I won't compromise on the work in any way, I somehow become less interested in colouring.' Occasionally his wife will colour one of his originals, but not third parties. Very rarely he will do the lettering in addition to the artwork. 'But I prefer not to because it's a real chore. It's a very specialized skill.'

Wrightson's studio features a great assortment of suitably ghastly bric-a-brac — skeletons, animals' skulls, pickled reptiles and interesting finds. 'That's just furniture, stuff to have around. I don't think of it as inspiration any more. Jeff Jones was given a boar's head a couple of years ago, and he thought it was just the ugliest thing, so he gave it to me because he knows I like ugly stuff.' For a few years in the second half of the 1970s, Wrightson shared The Studio with Jeff Jones, Michael Kaluta and Barry Smith. 'My corner of The Studio was the garbage heap for everyone else. They would bring all their refuse and their unwanted ugly things. Maybe they're talismanic in some strange way I refuse to admit, because if I did admit it I'd go completely crazy!'

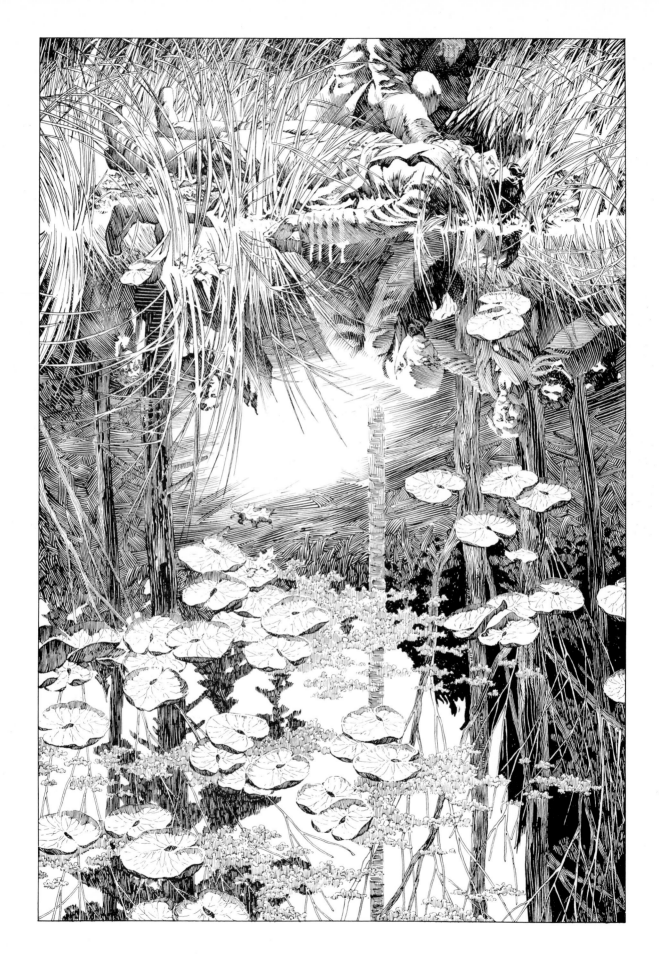

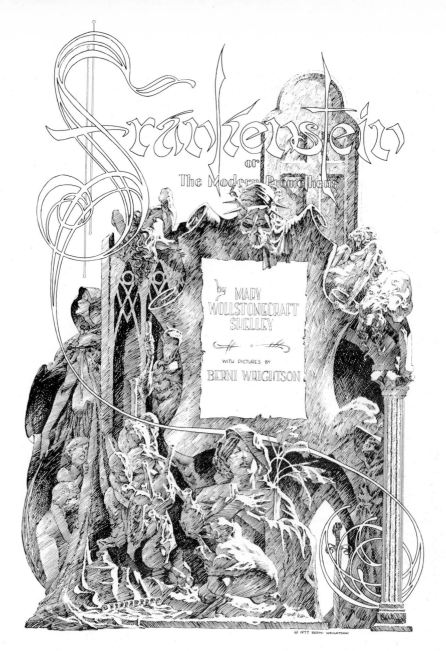

Frankenstein, *the title page.*

Despite the bizarre nature of some of the objects, as a whole they seem to have been selected less for their ghoulish qualities than their natural history and anatomical significance. Living things — even if only recently revived from the dead — always figure strongly in Wrightson's art, with ordinary human beings usually being the focus of a picture, whatever other strangeness or terror is lurking in the sidelines. This preoccupation with biology as opposed to technology remains true of Wrightson's excursions into more science-fictional pictures, where a spaceship might squat in a landscape of jungles or monsters, or a robot might have an organic look, as in *Metal Man* (page 110). The throb and pulse of life, be it natural or unnatural, is ever-present.

This picture was rejected from Berni's illustrated novel of Mary Shelley's Frankenstein. *He felt that it was confusing and without movement; but it is nonetheless enthralling.*

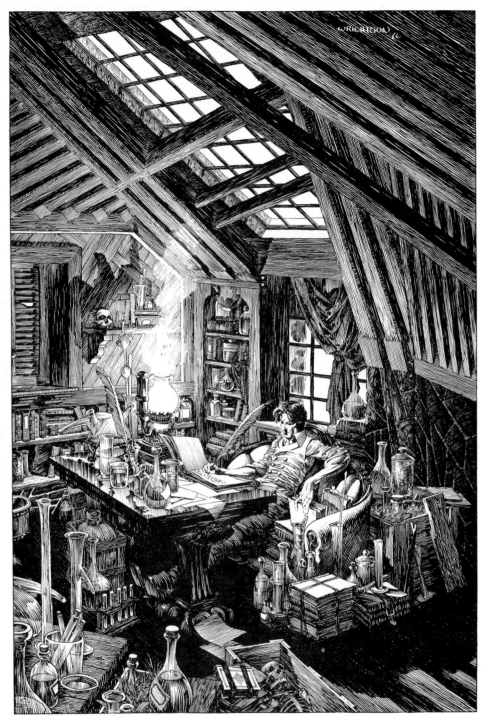

The stars often disappeared in the light of morning whilst I was yet engaged in my laboratory.

In the mid- to late 1970s, Wrightson broke away from comic-book art to experiment with styles and formats which weren't constrained by the genre. Among the projects that he undertook was a series of poster paintings which include *Counsel to a*

Minion, *Loggerhead* and *Taking No Chances*. They remain among Wrightson's favourite pieces.

Counsel to a Minion (page 114) features much of the fine ink-line work which has become one of Wrightson's trademarks. The thundery skies em-

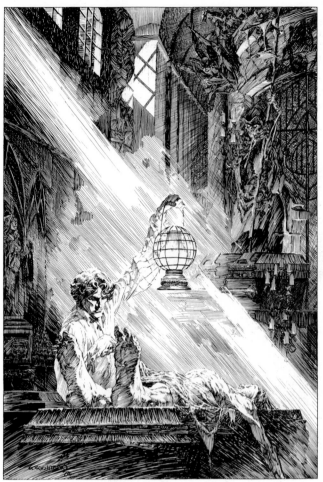

To examine the causes of life, we must first have recourse to death.

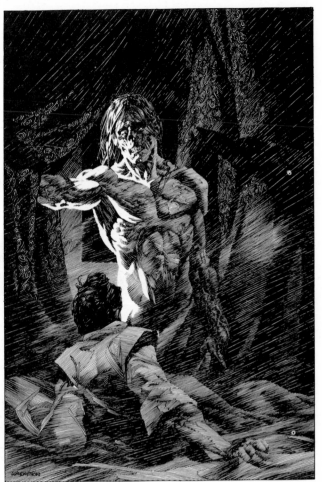

His eyes, if eyes they may be called, were fixed on me.

phasize the brooding quality of the picture, while the shadows which envelop the picture force the viewer to look more closely at its detail, focusing in on the faces of the three principal characters. The result is a very posed picture which is nevertheless filled with implicit activity.

Loggerhead (page 111) represents something of a departure, for it has an almost oriental look and contains none of the traditional imagery of horror or fantasy. Wrightson did the drawing on water-colour paper which he then soaked and stretched out on a board before he started putting on the colour. He was forced to work quickly as the stretched paper began to bow as it dried. The end result is a painting which looks almost tranquil until one realizes that the monstrous turtle is crushing the boat in its jaws. It also has the feeling of being filled with symbolic overtones.

'There's really not much of an idea behind it. It's only an extrapolation. It comes from real, large freshwater turtles that are thoroughly aquatic and spend the whole of their lives in the water. They build up algae and amazing colonies of little worms growing in their shells. So they become like this

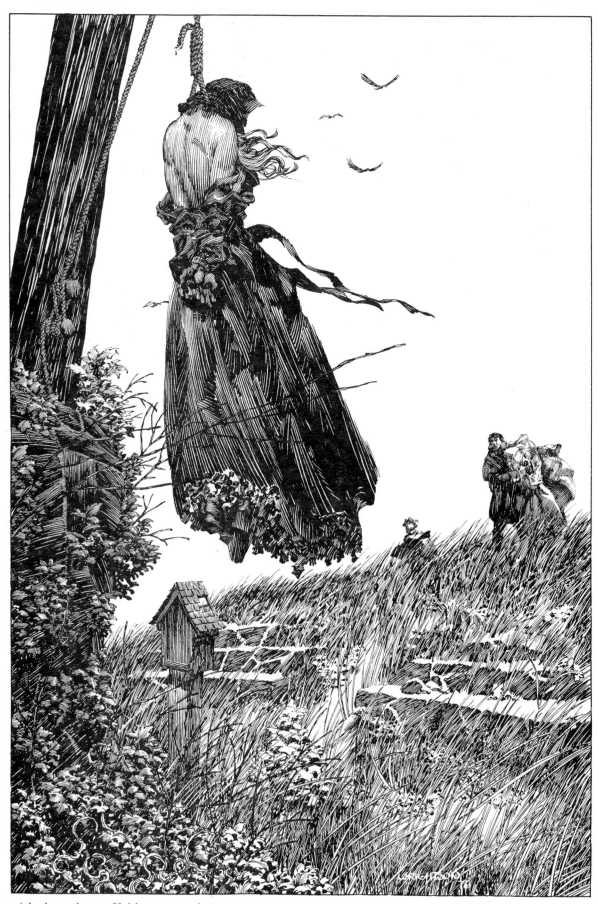

She perished on the scaffold as a murderess!

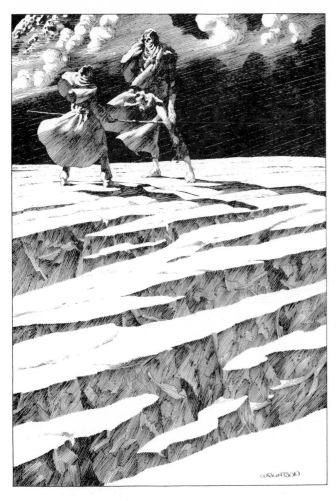

It was the wretch whom I had created.

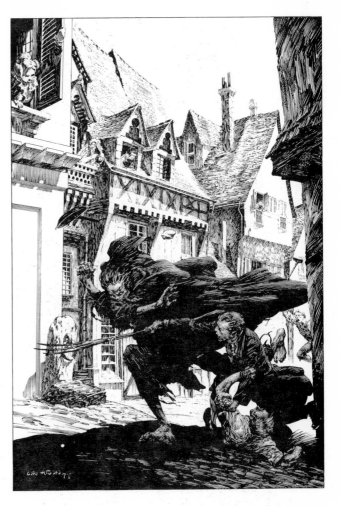

Grievously bruised by stones and many other kinds of missile weapons, I escaped to the open country.

moving, underwater island. The picture is an over-blown version of that. I just made the turtle larger, more primordial.'

A far less tranquil picture is *Taking No Chances* (page 115), where the colours are starker and the action leaps out at the onlooker. It was executed as an overtly commercial piece, and the title empha-sizes the joke, for the vampire's assailants hold a cross, a stake to drive through his heart and an axe to lop his head off. In addition, there's a large and conspicuous bunch of garlic close at hand so that everyone is well protected against the creature. The use of large areas of black heightens the light and colour elsewhere in the illustration, giving it an almost stained-glass radiance.

In 1983 Marvel Comics published Wrightson's illustrated version of Mary Shelley's *Frankenstein*, the culmination of a six-year endeavour for the artist. 'It was always my own project, my own idea. Originally I was going to publish it myself until I came to my senses.' Why the fascination with the project?

'I can thank one person for this, and it's Boris Karloff. When I was very little, I saw the original

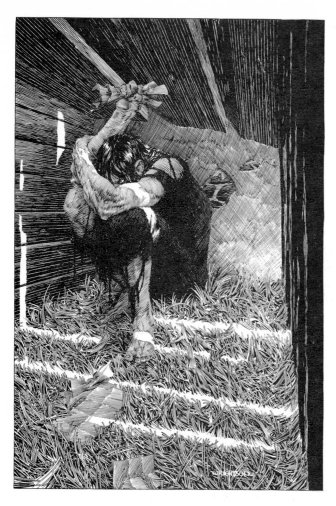

'Accursed creator! Why did you form a monster so hideous that even you *turned from me in disgust?'*

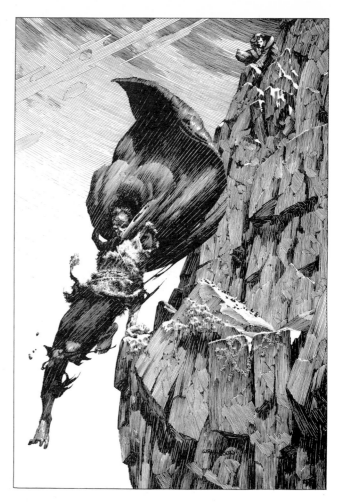

I saw him descend the mountain with greater speed than the flight of an eagle.

Frankenstein on TV, the black-and-white 1931 version. It was just one of those moments when I felt my life change in some way. I didn't at that moment think ''I am going to illustrate the book'' because I was only seven years old. But it affected me very, very deeply. I wasn't frightened by it. I felt sorry for the monster. There was something much more to it than a scary face. He was a victim.'

Did he see it as being rather like a Shakespearean tragedy? 'Exactly. But brought into terms that a seven-year-old could understand. And it stuck. It found a corner in my mind and just stayed here. And I'm sure that's where a lot of my fascination with horror *per se* comes from. It all stems back to my childhood, sitting in front of a black-and-white television set, watching *Frankenstein*.'

Wrightson always intended that the illustrations would be black and white, and he adopted a style relying almost totally on pen-and-ink line work to create the pictures. Even the areas of deep shadow and darkness in most of the illustrations are contrived with varying degrees of cross-hatching rather than the use of flat black. The effect is a look which

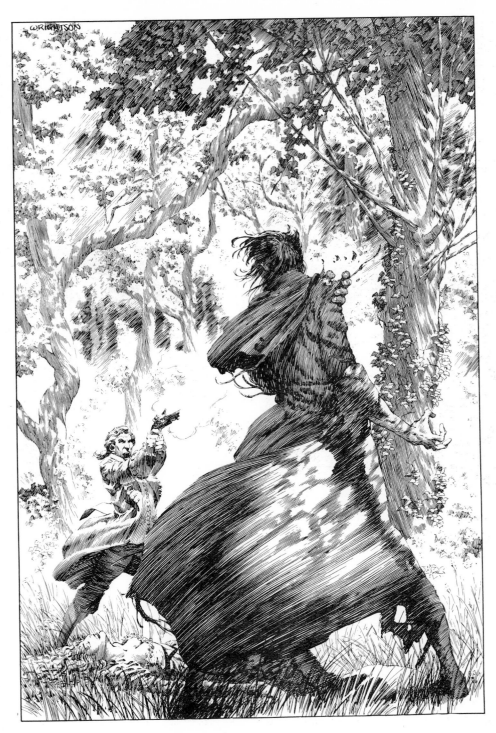

When the man drew near, he aimed a gun,
which he carried, at my body, and fired.

varies between the grainy and the metallic.

'It was partly because I wanted something that fitted the tone of the time period of the book. When the book was first published in the early 19th century, there was no colour reproduction — or if there was, it was very sparse and probably done by hand. Most of the illustrations you saw in books were woodcuts or possibly steel engravings. I was trying to mimic that look.'

Many of the pictures are remarkably detailed,

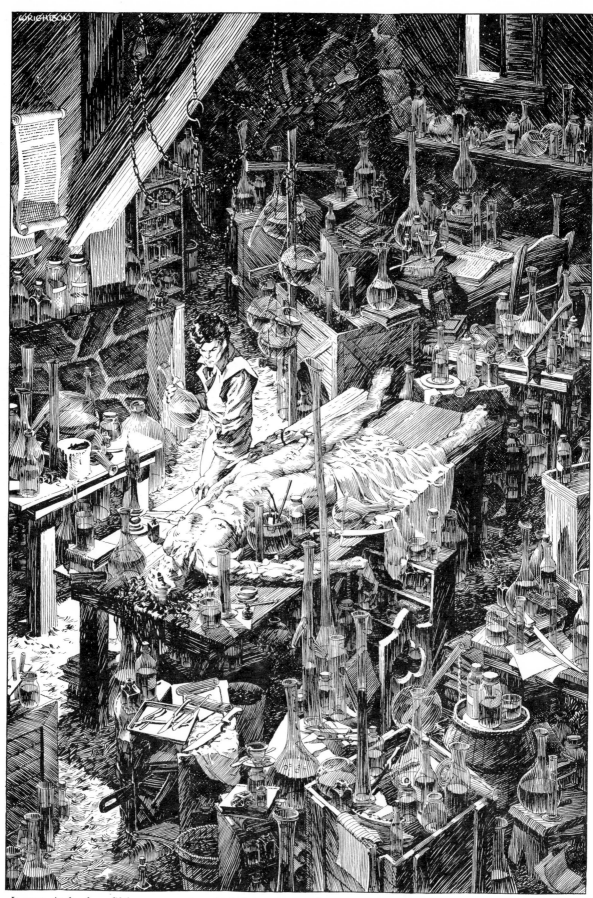

It was, indeed, a filthy process in which I was engaged.

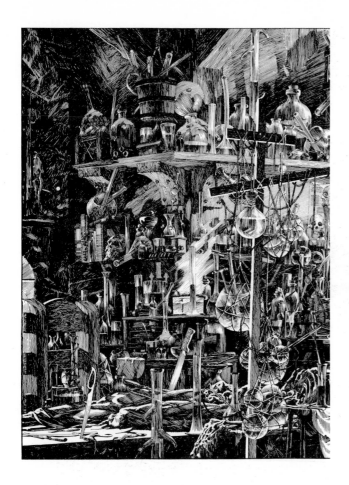

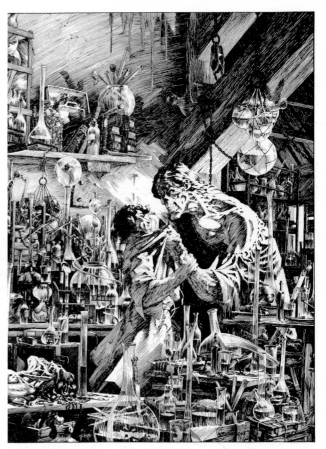

'I shall be with you on your wedding night.'

from the incredible clutter of glassware in Frankenstein's laboratory to the external scenes in which every blade of grass can be counted on the ground, every leaf on the trees. The entire task was very much a labour of love for Wrightson, who rejected a number of finished illustrations which were excellent in their own right but which, for various reasons, he did not feel he wanted to include in the finished work.

'I had great problems in selecting which scenes to illustrate. In my collection of quick sketches in my sketchbook there are probably over a hundred drawings.' In the finished book there are less than half that number. Wrightson took great pains to achieve a convincing rendition of the monster, rejecting various pictures because the physique or features weren't right. He added modelling clay and rubber like rotten flesh to an old skull until he had the face he wanted. He was also concerned that the pictures should actually illustrate the words of the novel rather than being a fanciful rendition of it. Even so, the backgrounds, which sometimes have echoes of North American landscapes, owe something to the original cinematic inspiration.

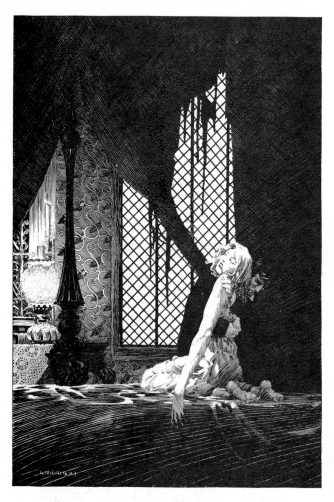

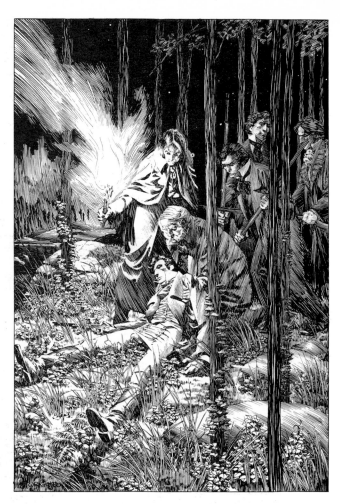

She was there, lifeless and inanimate, thrown across the bed.

I fell at last in a state of utter exhaustion.

'It takes place in a never-never land. There is absolutely no pretence that it's an accurate period piece. I did no research in the clothing or architecture or anything. This was purposeful. In my mind, it takes place in Europe, but in the Europe that I saw in black-and-white American-made movies, which was very stylized. I like that look.'

Though his pictures often portray the dark and supernatural side of human affairs, Wrightson retains a streak of irreverence about his work. In his living room hangs a picture which arose out of a conversation with a Catholic friend about the Sermon on the Mount. This was known in their catechism books at school as 'The Multiplication of the Loaves and Fishes', but Wrightson half imagined that his friend was saying 'The Meltification of the Loathsome Fishes' and the idea for a picture of that title immediately sprang into his mind.

'It's just a pun-painting. When it was finished, I hung it in my living room. Every day, when I sit on the couch and look at that painting, I giggle at it. Give me a better reason for a piece of art to exist.'

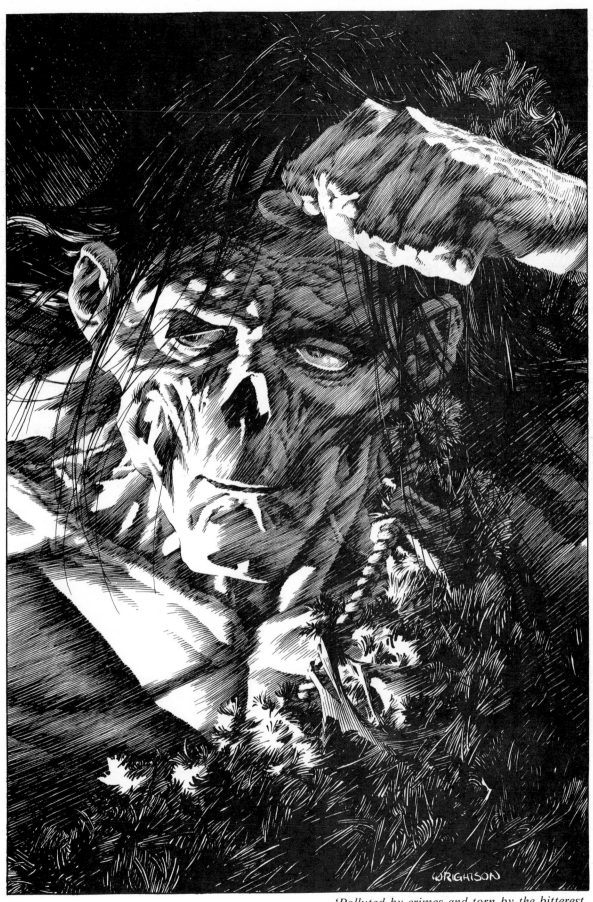

*'Polluted by crimes and torn by the bitterest
remorse, where can I find rest but in death?'*

127